Infrared Photography Handbook

Laurie White

AMHERST MEDIA, INC. ■ AMHERST, NEW YORK

Published by:
Amherst Media Inc.
P.O Box 586
Amherst, NY 14226
Fax: 716-874-4508

Publisher: Craig Alesse
Editor/Designer: Richard Lynch
Editorial Consultant: Dan Schwartz, J.D., Ph.D.
Layout: Frances Hagen
All photos and diagrams by: Laurie White

ISBN 0-936262-38-9
Library of Congress Catalog Card Number: 95-79716

Printed in the United States of America
10 9 8 7 6 5 4 3 2 1

for Christian, whose confidence inspires...

Table of Contents

Introduction

Seven years ago, I loaded a roll of infrared film into my camera and, with no idea of what I should do, shot it all. Most of the roll was a failure. The few good shots, however, were so dramatic and aesthetically compelling that I abandoned standard black and white photography and concentrated almost exclusively on infrared.

Every day, the sun pours down a flood of infrared radiation. We walk through it, blind to the dreamlike world dangling just beyond our ability to perceive it. The delight of infrared photography is that it gives us a window into this unexplored world. No other film can produce such a wide range of imagery, from realistic studies to unearthly landscapes and silken portraiture.

However, infrared presents a rather sinister challenge since the light the photographer sees and the light the film responds to are not the same. Shooting with infrared film requires the photographer to learn a whole new way of seeing.

In this book, I hope to provide you with a comprehensive understanding of visible and invisible light and the techniques that will lead to success in photographing them. I will explain the equipment you will need, which filters to use, as well as how to focus, select appropriate subjects, recognize suitable light sources, and choose your ASA/ISO rating. I will isolate all the variables that affect infrared film and explain how they impact the final image, giving you a solid and informed basis for your artistic endeavors.

This understanding will get you started down the road of previsualizing the results. By giving you the knowledge to make intelligent choices before the picture is taken, you will take charge of the creative aspects of picture making. You can reduce the role that blind luck has traditionally played in infrared photography. With the techniques from this book, there will be nothing to stop you from going out there and capturing the invisible world on film.

Good luck!

Laurie White

Section I:

Basic Theory: Taking Your First Roll of Infrared

Before you run out and start shooting roll after roll of infrared film, it is important to review some basics that will aid you in your ability to make informed decisions about exposing in infrared.

This first section is an overview of light theory important to infrared photography. It includes the following information:

- The visible and infrared light that exposes infrared film

- The Spectral Sensitivity of infrared film and how visible color helps in determining infrared exposure

- Filters in visible and infrared photography

- Focusing in visible and infrared photography

In this section, we will also review the basic equipment required to begin shooting in infrared and discuss the steps necessary to successfully expose your first roll of infrared film.

CHAPTER ONE

Learning to See in Infrared

The Electromagnetic Spectrum

What we commonly think of as "light" is just a small portion of the energy produced by our sun. This energy flows out in a vast range of particles and waves called the ELECTROMAGNETIC SPECTRUM. At one end of this spectrum are extremely powerful rays, such as gamma rays and X-rays. At the other end, we find less exotic energy in the form of radio and microwaves.

Between these two extremes is a narrow region that our eyes are capable of seeing. This VISIBLE SPECTRUM is what we commonly call light.

Each color we see is defined by a CHARACTERISTIC WAVELENGTH ▼. Shorter wavelengths (around 400nm) are blue, while longer wavelengths (around 700nm) are red. While we perceive most daylight, or artificial light as "white" light, it is in fact the combined luminance of all the different wavelengths (colors) of visible light that we see as *white*.

The PHOTOGRAPHIC SPECTRUM is the range of wavelengths that can expose film. Since the Photographic Spectrum is larger than the Visible Spectrum, portions of the Photographic Spectrum are invisible to us.

Photographically, two kinds of invisible light are significant. At wavelengths shorter than the deepest visible blue we find the Ultraviolet. Invisible to our eyes and our light meters, UV is nevertheless seen by all films and tends to impart a hazy look to landscapes. Infrared light is on the other end of the spectrum. These wavelengths are longer than the deepest visible red light and expose only the few films sensitive to this region.

▼Wavelength

Light is a wave and we can measure the distance from the crest of one wave to the next. This distance is the *wavelength*. We measure visible wavelengths in *nanometers* (nm), one-millionth of a millimeter. The size of the wavelength defines the type of electromagnetic energy radiating from the sun. In the visible spectrum, different colors of light have different wavelengths. So by simply knowing the wavelength of a particular light wave, we know both its color, and whether or not it is a part of the visible spectrum.

The sun produces an enormous range of energy called the Electromagnetic Spectrum.

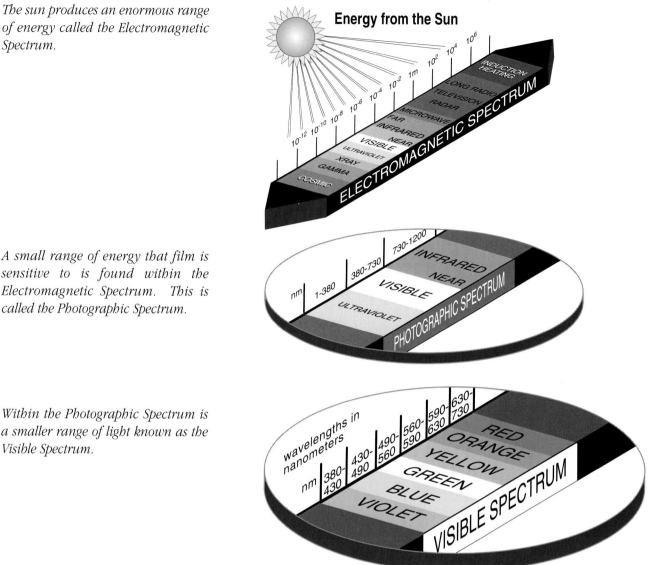

A small range of energy that film is sensitive to is found within the Electromagnetic Spectrum. This is called the Photographic Spectrum.

Within the Photographic Spectrum is a smaller range of light known as the Visible Spectrum.

• The infrared spectrum has two sections: Near and Far.

The INFRARED SPECTRUM itself is divided into two sections — near and far. FAR INFRARED is what we feel as heat, whether from the sun, a hot iron, or a warm body. This is *not* the infrared light that infrared films record. The infrared that exposes our film is the portion of infrared near the visible spectrum, or NEAR INFRARED. This region lies between the visible and the far infrared. We cannot see or feel it in any way.

Film Sensitivity

• Infrared films are also sensitive to the Visible Spectrum.

Like our eyes, films are designed to be sensitive to specific portions of the electromagnetic spectrum. Normal black and white films are called "panchromatic," meaning that their emulsions are sensitive to many colors. There are a few "extended red sensitive panchromatic" films that cover the normal range of black and white films, then venture into the infrared by 30 or so nanometers. Infrared films are sensitive to the *entire* visible spectrum, plus 200nm beyond visible light into the infrared region.

▼Infrared Light

The infrared region of the electromagnetic spectrum begins just out of visible range for humans. Beyond the longest visible red wavelength, infrared light occurs from 700nm to 1 million nm (1mm). Infrared light is broken up into two regions, near infrared and far infrared. The near infrared, from 700 to 1200nm (wavelengths closest to the visible spectrum), cannot be detected by the human eye. Far infrared, from 1200nm to 1mm, is invisible to the eye and can be felt as heat.

As the Visible Spectrum spans only 350nm, infrared film's additional 200nm of sensitivity seems substantial. However, when we look at the entire range of INFRARED LIGHT ▼, we find our infrared film is sensitive only as far as 900nm, a limited portion of the *near* infrared. Long before you can feel infrared light as heat, your film has stopped being sensitive to it.

Spectral Ranges of Film Sensitivity

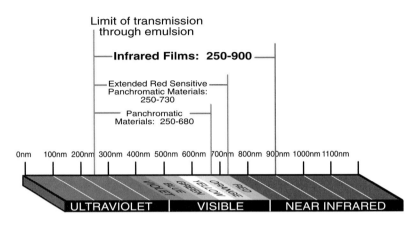

This graph shows sensitivity ranges for different photographic media. Most black and white films are "panchromatic," sensitive to all colors of visible light as well as ultraviolet radiation. There are a couple of "extended red sensitive panchromatic" films which add to the panchromatic range a touch more sensitivity to red light.

Finally, note the sensitivity range of infrared film. It stretches from well into the ultraviolet region, through the visible spectrum, and substantially into the near infrared portion of the spectrum.

Color is Reflected Light

The light that illuminates an object or scene is called the SOURCE LIGHT. Each source light emits a signature spectrum of colored light wavelengths. Sunlight's signature spectrum contains all visible wavelengths, as well as ultraviolet and infrared. In contrast, a candle flame emits only yellow, orange, red and infrared wavelengths.

When a source light falls on an object, some wavelengths are absorbed by the object, while others are reflected. It is the REFLECTED WAVELENGTHS of light that we perceive as the object's color. When no light illuminates an object, or when none reflects, we see it as dark or black.

In order for us to perceive the true color of an object, it must be illuminated by wavelengths of light that include the colors the object will reflect. If the source light contains only a portion of these reflective wavelengths, then we will see a false representation of the object's color. If the source light contains none of the wavelengths the object will reflect, we will see the object as black. The color of any subject is a combination of the light illuminating it and how the subject reflects that color.

• **The color of objects depends on:**

1. **the color of light striking the object, and**

2. **the wavelengths of light the object reflects.**

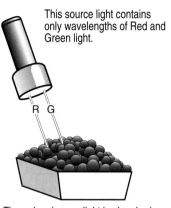

Here the white source light contains wavelengths of Red, Green and Blue, abbreviated as R, G, B.

R G B BLUE!

This source light contains only wavelengths of Red and Green light.

R G

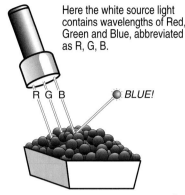

• The blueberries absorb the red and green light, while reflecting the blue light.
• We see the berries as blue.

• The red and green light is absorbed, none is reflected.
• We perceive the blueberries as black.

Reflection doesn't end with the visible light spectrum. Your source light can also include ultraviolet and infrared radiation. The object is bombarded with these wavelengths and will either absorb or reflect them.

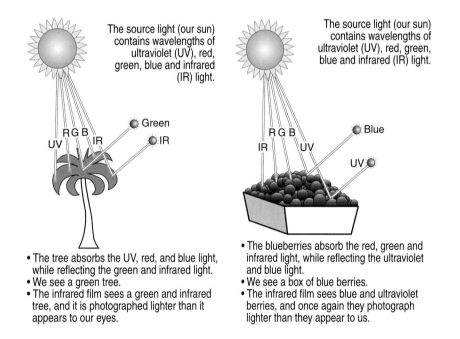

The source light (our sun) contains wavelengths of ultraviolet (UV), red, green, blue and infrared (IR) light.

Green
IR
UV R G B IR

• The tree absorbs the UV, red, and blue light, while reflecting the green and infrared light.
• We see a green tree.
• The infrared film sees a green and infrared tree, and it is photographed lighter than it appears to our eyes.

The source light (our sun) contains wavelengths of ultraviolet (UV), red, green, blue and infrared (IR) light.

Blue
R G B
IR UV
UV

• The blueberries absorb the red, green and infrared light, while reflecting the ultraviolet and blue light.
• We see a box of blue berries.
• The infrared film sees blue and ultraviolet berries, and once again they photograph lighter than they appear to us.

Color's Role in Infrared

A photograph captures the light that reflects from a scene. In black and white, colors are rendered as an array of grey tones. With infrared film, colors and infrared radiation are also rendered as grey tones.

• **Visible color is your clue to infrared exposure.**

Discerning how much (or how little) infrared light is reflecting from your scene is an acquired skill. Visible color, both of the subject and in the light illuminating the subject, will be the clue you use to predict the infrared content of a potential picture.

In order to use visual colors as clues to infrared content, you must know which colors will expose your film. This is known as the film's SPECTRAL SENSITIVITY.

Measuring a Film's Response to Colors

Spectral sensitivity is a measurement of a film's sensitivity to different wavelengths of light across the photographic spectrum. In other words, a given film will be more sensitive to some colors and less sensitive to others. When a film's spectral sensitivity curve is plotted along the photographic spectrum, it shows us the film's sensitivity at each wavelength.

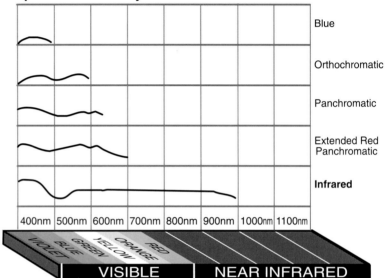

Films are designed to be sensitive to specific portions of the photographic spectrum. Blue sensitive films are exposed by wavelengths at the blue end of the spectrum. Orthochromatic films are exposed by blue, green, and yellow wavelengths.

More common films such as panchromatic are sensitive to all colors, while extended red panchromatics are sensitive to all colors right up to the infrared region. Infrared is additionally sensitive to a portion of the near infrared region.

- **Infrared film is more sensitive to *blue* light than infrared light.**

Infrared film is evenly sensitive to infrared, red, orange and yellow light. Its sensitivity wanes in the green region of the spectrum, while it is most sensitive to the ultraviolet and blue wavelengths. If you shoot infrared film under normal daylight conditions, the ultraviolet and blue light in the scene will overwhelm any infrared radiation recorded on your negative. The end result won't represent the infrared record of the scene, it will resemble an ordinary black and white photograph.

Since our goal is the singular look of infrared photography, we need a weapon against unwanted light. That weapon is the filter.

The Filter's Role in Photography

Filters are used in standard black and white photography to enhance the contrast of the scene. With infrared photography, we use filters to block some (or even all) visible light and in doing so, open a window through which we can photograph the invisible.

Filters work on a simple premise. A filter transmits the wavelengths that make up its color and blocks all other wavelengths, to a greater or lesser degree. This allows us to select which portions of the photographic spectrum we will block or enhance.

Sunlight is made up of light of many colors as well as ultraviolet and infrared. The filter blocks specific wavelengths (colors) of light while allowing other wavelengths to pass through. This gives more exposure to those objects reflecting the same color light that the filter transmits, while darkening objects reflecting colors that the filter blocks.

How a Filter Works:

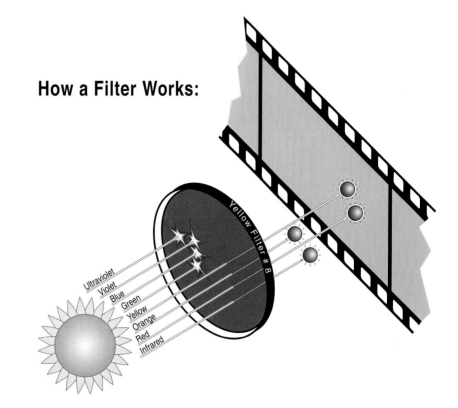

Ultraviolet
Violet
Blue
Green
Yellow
Orange
Red
Infrared

Yellow Filter # 8

Filters Can Be Deceiving

- This tree is illuminated by white sunlight, containing ultraviolet, red, green, blue and infrared light. The UV, blue and red are absorbed while the green and infrared are reflected.
- Our eyes perceive a green tree, but the tree is also reflecting infrared. The film will see a different color tree than we do.
- If we use a red filter, which blocks green light, our eyes see a dark tree, while the film sees the infrared light and the tree is exposed much lighter than we would expect.

Black?

1) The visible green light cannot pass through the red filter.

2) Infrared light passes through the red filter and exposes the film.

3) When you look through the camera with the filter on the lens, the tree appears dark.

RGB
UV IR G
IR

Red Filter # 25

4) When you develop the film, the tree will appear white.

13

Black and white films are more sensitive to blue light than red light. Therefore, blue objects and areas, such as the sky, tend to overexpose the negative and appear much lighter in the print than they do to the eye. Using a yellow filter provides a slight correction. Using an orange or red filter can render the scene more dramatic, darkening skies and increasing the contrast between light and shade.

Infrared Light Focuses at a Different Point than Visible Light

• **"White light" is composed of many different colors of light.**

When white light is shone through a prism, the light waves bend a different amount depending on their wavelength. As the light exits the other side of the prism, the waves bend even more, creating the familiar rainbow effect. The red wavelengths are the longest and bend the least. The violet wavelengths are the shortest and bend the most. This bending of light waves, or REFRACTION, occurs every time light passes through glass, such as a filter or your camera lens.

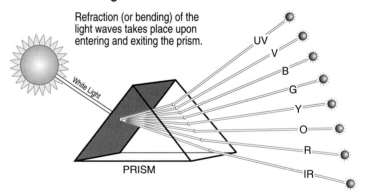

Refraction of Light Waves

Refraction (or bending) of the light waves takes place upon entering and exiting the prism.

White Light

PRISM

UV
V
B
G
Y
O
R
IR

Refraction occurs when light enters and when it exits <u>any</u> piece of glass. The shape of a prism bends the light in such a way as to cause the spectrum of light (violet, blue, green, yellow, orange and red) to be visible.

Refraction is what allows us to focus an entire scene onto a piece of 35mm film. However, since each wavelength of light bends a specific amount, they all focus at different points behind the lens. Compensating for the refraction, lenses are ground and coated to focus all colors onto the film plane.

• **Most lenses are not corrected for infrared light.**

While this chromatic correction benefits the visible light photographer, it does nothing to focus infrared wavelengths onto the film plane. A simple adjustment of the focus ring is needed to compensate for this difference in refraction.

Refraction (bending of the light rays) occurs when the light enters and again when it exits the glass of the lens. Each color of light bends a specific amount based on the length of its wave, thus causing each color to focus at a different point behind the lens.

Colored coatings and lens grinding minimize this effect in the visible spectrum. However, to bring the infrared portion of our exposure into focus, we must adjust the distance with the focus ring.

Primary and Infrared Color Focus
Through an Uncoated Lens

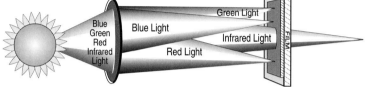

Primary and Infrared Color Focus
Through a Corrected Lens

Useful facts about light and color:

- Visible light is a segment of the electromagnetic spectrum.

- Films can photograph beyond our visual range into UV and infrared.

- Color is the wavelengths of light that reflect from an object.

- The color of an object can give you clues to its infrared reflectivity and how it will expose in infrared.

- Each type of film responds differently to color. A film's spectral sensitivity curve reveals its sensitivity to each wavelength.

Basic concepts of controlling light:

- Filters can be used to prevent certain wavelengths of light from reaching the film.

- Filters can temporarily alter a film's sensitivity curve.

- Caution! Viewing a scene through a filter can block significant clues about how an object will photograph in infrared.

CHAPTER TWO

The Tools: Film; Camera; Filters; Tripod; Black Bag & Light Meter

Film Choices

Black and white infrared film is manufactured by Eastman Kodak and Konica. The Kodak film is available in the following sizes: 35mm magazines with 36 exposures; 150ft rolls (2481); and 4x5 sheet film (4143). The Konica film comes in 35mm magazines with 24 exposures, and 120mm with 12 exposures. You can find them at most professional photographic supply stores.

- **Load Kodak High Speed Infrared film only in complete darkness.**

The Kodak negative itself is a very thin, pale green emulsion which lacks the anti-halation/anti-curl backing found on most other film stocks. This makes the film more susceptible to flashing or fogging if loaded in sunlight. Even subdued light can expose or fog your infrared film because the long wavelengths of infrared light make their way through the hairs of the velvet light trap on the film canister itself. Kodak infrared should only be removed from its plastic container and loaded into your camera in a black bag.

- **Konica 750nm can be loaded in very subdued light.**

The Konica infrared film sports an anti-halation backing, and consequently, can be *cautiously* loaded in subdued light.

While the infrared photographic theory in this book is applicable to all infrared film, experience has demonstrated that the Kodak stock is more versatile and pictorially pleasing. Consequently, all specific recommendations refer to the use and characteristics of the Kodak High Speed Infrared, unless otherwise noted. In shooting your first rolls, use Kodak film as you will achieve good results under a wide range of conditions.

Most fixed focal length lenses have a separate dot or line indicating the infrared focus point. Some zoom lenses have a stripe along the barrel for adjusting focus.

Camera Options

Most 35mm cameras can be used for infrared photography. A 4x5 view camera is another option, but should be tested for light leaks in the bellows. Also, cameras accepting 120mm film can be used with Konica infrared film.

Your best option is to use a completely manual camera for easy adjustment of exposure and focus. If you only have access to an automatic-type camera, consult the manual for details about focusing and the default ASA/ISO (see Chapter Six). Be aware that some automatic cameras use small infrared sensors inside the camera body to facilitate film handling. The sensors may expose your infrared film, making these cameras unusable for infrared photography.

Camera lenses are designed for focusing wavelengths of visible light. Because infrared light is made up of longer wavelengths, the infrared rays focus at a point slightly behind the focal point for visible rays. Consult your camera manual for information on infrared focusing. Typically, each lens has a separate focus mark for infrared. Zoom lenses will have a line on the lens barrel. Focus visually, then rotate the focus ring until the focal distance lines up with the infrared marking instead of the standard mark.

The Best Filter to Start

Since infrared film is actually *more* sensitive to visible blue light than it is to the infrared wavelengths, filtration is a key element in obtaining a characteristically infrared image.

There are two types of filters available — visible light filters and infrared only filters. The visible light filters are standard black and white filters, ranging from yellow to orange and red (Wratten #8, 15, 25, 29). For a pure infrared effect, the infrared filters (#89B, 88A, 87, 87C) are completely opaque to visible light, and pass only the infrared wavelengths to the film. In other words, you can't see through them, but your film can.

If you choose an opaque filter, the scene must be framed and focused. Lock the camera down on a tripod before applying the filter.

- **The best all-purpose filter is the #25 red.**

The #25 red filter is the most versatile of the recommended filters for pictorial photography. You will achieve the distinctive infrared look while still being able to compose and meter the light through your camera.

A Tripod for Sharper Images

- **Deep depth of field ensures successful infrared focusing.**

Focusing is the bête noir of the infrared photographer. Even under the best conditions (totally static scene, lots of sunlight) you will not know if the subject is in focus until a reasonable size print is made. You may also find that even when your subject is sharp, any large out of focus areas in your frame are quite simply ugly. This is due to the emphatic grain structure of the infrared.

▼Depth of Field

Depth of Field refers to the range of sharpness before and behind the plane of focus. In other words, how much of the scene in front of and behind your subject will remain sharp in the final image. At each focal length, a specific f-stop will keep a given range in focus. As your f-stop becomes bigger (f16, f22, etc.) the depth of field gets larger. Wide apertures, f4.0, f2.8, f2.0, etc. give you very little depth of field.

The range of sharpness differs with each type of lens. For a zoom lens, the depth of field lies 1/2 in front of the set focus and 1/2 behind. With a fixed focal length lens, 1/3 of the depth of field is in front and 2/3 behind.

• **Test your black bag for infrared light leaks.**

To overcome these liabilities, you must shoot at a high f-stop to maintain a large DEPTH OF FIELD ▼. At times, this will cause you to shoot at 1/15th or 1/8th of a second, speeds which typically require a tripod.

Set your focus to include prominent foreground objects, your subject, and any significant objects in the distance. A large depth of field will help to maintain focus throughout the scene.

Light Meters Give You a Place to Start

A basic problem the infrared photographer faces is that light meters are designed to meter visible light. Consequently, your light readings are only a jumping off point for your actual exposure. Whether incident or reflected, through the camera or hand-held, use the kind of metering with which you are most comfortable. Having one familiar constant will give you a benchmark from which you can explore the possibilities of infrared film.

When you work with infrared film, you are operating outside the science of photography and approaching something very much like Zen. Most of your exposures are a combination of visible and infrared light, so you will learn to rely on your judgment and not on photographic technology.

Black Bags Provide a Portable Dark Room

A small changing bag is essential for infrared photography in the field. Since black bags are designed to block visible light, some have proven transparent to infrared. Rubber lined bags are the best as they block *all* light, visible and infrared. If you already own a bag, make sure you test it by loading and unloading a roll of infrared in direct sunlight. If streaks of light appear on the film after developing, then your bag is not infrared proof.

Basic Equipment You Need to Start:

• Film — Kodak or Konica

• Camera — manual controls, if possible.

• Filters — see appendix for types and manufacturers.

• Tripod — always use a tripod to achieve the utmost depth of field.

• Light meter — employ your usual mode, remembering that it is only a guide as the meter cannot see infrared.

• Black bag — always load and unload your film in the dark.

CHAPTER THREE

Getting Started: Loading infrared film; Exposing your first roll; Analyzing your work

Successfully Loading and Unloading in the Dark

Since you will be relying on your sense of touch while loading and unloading your infrared film in the dark, use an expendable roll of film and practice with your hands in the black bag or with your eyes closed.

Loading Guidelines:

- **When using the black bag outdoors, sit in the shade or a sheltered area, not in direct sunlight.**

- **Save the original black infrared film container – grey top containers may leak light.**

- **Clean your black bag regularly.**

Find a flat surface for your black bag. Your lap will do, but can be a bit awkward. Don't use the bag in direct sunlight if at all possible; a bag that seems perfectly light-tight in the shade can be a sieve in full sunlight. Place the plastic film container and the camera into the black bag. Close both zippers and turn the exposed zipper under the bag to prevent any light leaks through the zipper.

If you have a luminous watch, remove it as it could expose the film. Remove any potentially sharp jewelry to avoid scratching the pressure plate or damaging the light-trap. Any irregularities on the surfaces inside your camera body are potential traps for dust that may later scratch your film.

Push your arms deep into the bag, and keep the elastic arm cuffs out of sunlight to prevent light leaks. As you place the film in the camera, be careful not to touch the shutter—it is very delicate and contact can dislodge it, causing inaccurate exposure.

• **Kodak Infrared negative is thin and easily damaged.**

The infrared negative is thinner than other films, so it is more difficult to handle. It can shed pieces of emulsion that will hitchhike through your shots, leaving scratches or spots. Make sure the film is firmly threaded onto the take-up spool. Double-check this by backwinding the canister to take up the slack. Close the camera and feel around the door to ensure that the black bag's fabric has not been caught. With your finger on the rewind knob, shoot an exposure and advance the film to make sure the film is advancing properly. Remove the camera from the bag.

Once the camera is in the light, shoot a second blank exposure, visually ascertaining that the rewind knob is turning. Because you've loaded in a black bag, there's no need to advance three exposures. You're ready to shoot.

• **Don't use grey-topped containers to store infrared film.**

Save the black film container to protect your exposed roll. Don't substitute a grey-topped container as they are not light proof. Additionally, the printed warning should help keep the curious from opening the container and ruining your work.

Keep your black bag clean by shaking or vacuuming with a hand-held attachment. Any dust you miss will surely find its way onto the best shot of the role. Finally, protect your black bag by folding it correctly. The idea is to protect all seams and the zipper by folding them into the middle of the bundle.

Unloading Guidelines:

• **Unload in the black bag.**

• **Label the container "exposed infrared" so no one will accidentally open it in the light ▼.**

• **Check inside the camera body for dust, dirt and emulsion pieces.**

▼**Container Label**

Below is a sample of the label found on top of the infrared container. The label warns that the film in the container must be handled in total darkness. When you unload your exposed roll, make sure you place it back into the container and immediately write "exposed" on the lid.

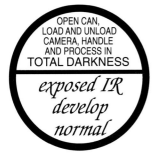

OPEN CAN, LOAD AND UNLOAD CAMERA, HANDLE AND PROCESS IN TOTAL DARKNESS

exposed IR develop normal

When you finish exposing the roll, rewind your film with a slow, even pressure. When ready to unload, place the empty black film container in the bag with the camera you want to unload. Open the camera door and remove the exposed roll. Place the film in its container, and double-check that the cap is fully seated before opening the bag. It is good practice to label the exposed container immediately.

If you are in a sheltered, clean environment, remove the camera and give it a quick once-over, removing any sand, dirt or dust particles. If you're in the field and there's no time to be fastidious, you can unload the exposed roll and load a new roll without exiting the bag. However, upon removing the exposed roll, immediately place it into a container. This eliminates any chance that you might load the camera, unzip the bag and discover the exposed roll only when it falls into the light.

If you are always in the field and keep loading roll after roll in the bag, it's entirely possible to never see the interior of your camera. Make time to check it over. Cameras usually *feel* cleaner than they actually are.

Shooting Your First Roll

Achieving a striking or unusual image using infrared film is not particularly difficult. Almost every roll of infrared will yield at least one exciting photo. The challenge of infrared photography is to improve the ratio and turn out an entire roll of interesting images. In order to avoid the period of intermittent success and continuous frustration, I suggest using a formula to get started.

The final outcome of an infrared exposure is dependent upon a number of variables. Adhering to the following suggestions gives you a starting point where these variables are fixed, and your exposures will turn out in a fairly predictable manner. Then, by experimenting with a single variable at a time, you will quickly develop your own store of experience to draw upon.

A Foolproof Way to Get Results

Place a #25 red filter on your camera and go outside at noon on a sunny day. A park is a good place to start. It gives you sun and open shade, and a variety of people and man-made structures.

Take a notebook along and record the details of each shot you take. Make notes about lighting conditions: What in your photograph is in direct sun, partial sun, shade and deep shade. Jot down the visible colors of any objects, trees, clothing, or buildings in your photos.

Though you will not be using your light meter to decide exposure on this roll, set the ASA/ISO on your camera to 200. If you are using an incident meter or a hand held spot meter, ASA/ISO 50 is the proper setting after the filter factor calculation (see page 52).

- **Use a #25 red filter.**

- **Shoot outdoors on a sunny day.**

- **Shoot the entire roll at f11, 1/125th sec.**

- **Shoot a wide variety of subject matter in full sun and in shaded areas: people, trees, water, animals, buildings, grass, flowers, etc.**

- **Take accurate and detailed notes about exposure readings and the light illuminating the scene, but do not change your exposure.**

• **Shoot a first roll at f11 and 1/125th sec. Keep detailed notes.**

As you shoot, note the exposure your light meter suggests, but do not alter your speed or aperture. Expose the whole roll at 125th sec, f11 to keep a constant exposure under constant source light conditions. Even in deep shade, reflected sunlight or skylight is still the source of illumination. Your notes of light readings will illustrate the difference between the light your meter detects reflecting from the scene and the light that exposes your film.

Log Book *Kodak High Speed Infrared exposed at f11, 1/125 second through red #25 filter*

Exp#	Time & Sun Direction	Meter Reading	Subject -- include color details
1	1pm/over left shoulder	5.6 & 1/3	green leafy tree crosslight, dark green water, green grass
2	1pm/over & behind	5.6	same leafy green tree, frontlight, green grass, dark grey cement walk
3	1pm/over left shoulder	5.6	green leafy tree, dark green water, grey dome with reddish columns
4	1pm/over & behind	5.6 & 1/2	pink shirt, black fanny pack, green leafy tree, green grass
5	1pm/deep shade	4.0	pink shirt in sun, blue shirt in shade, reflection in dark green water
6...	1pm/deep shade	2.8	toplit green leafy tree, photographed from within its deep shade
19	1:30/high, front right	5.6	backlit green leafy shrub in f.g., tree w/dark red leaves under urn in b.g.
20	1:30/over rt shoulder	8 & 1/2	deep blue sky, dark green foliage in f.g., reddish tan vertical columns
21	1:30/high on the right	8	reddish tan rotunda, green grass on either side of walkway
22	1:30/over rt shoulder	8	crosslit frieze, grass and gravel in f.g., blue sky in b.g.
23	1:30/high on the right	8	face lit by bounce off reddish column, blue sky, lt. green yuccas in b.g.
24...	1:30/behind, overhead	8 & 1/3	reddish tan columns, lt. green yucca, urn against blue sky in b.g.

Keep a log book like the one above and make detailed notes as you shoot the roll.
After you shoot the roll, take the film to a black and white lab and have a proof sheet like the one below made.

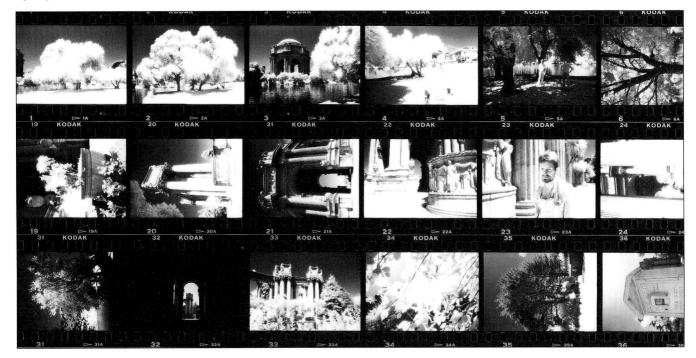

Take your film to a black and white lab, have it developed and a proof sheet made. Find out what chemicals the lab uses so you can request the same processing for rolls in the future. If you process your own negatives, use D76 and the proper time suggested on the chart in the appendix.

Analyze Your First Attempt

After developing, examine your exposures and compare the results with your notes. See how different subjects react. Some plants expose white, others remain stubbornly dark. One building seems strangely voluminous while another lies flat. A black dress can turn completely white, and even dark red objects can glow to the point of halation. Perhaps most confusingly, some of your negatives may be extremely dense and grainy, while others seem sharp, even fine-grained.

Look for:

- Green leafy trees: Are they whiter than you expected?

- Grass and flowers: Did they turn white or remain true to their color tone?

- People: Are there differences between blondes and brunettes?

- Red objects: Are they all overexposed?

- Synthetic fabrics: Did they expose unexpectedly?

- Water: Is it transparent or opaque?

- **Use your first roll as a baseline.**

Variances in exposure are the single greatest factor in making or breaking an infrared photograph. Your first roll from the park will be your baseline, because you've eliminated fluctuations in exposure. Cross-index your exposure notes with the resulting photographs. You may find that a frame you thought was underexposed is actually right on.

Consider the photos you like the most. Are they a result of specific conditions: Full sun, frontlight, deep shade? Are certain subjects more interesting than others: Trees, architecture, people? Already you are starting to build a catalog of examples that will influence your future decisions.

Experiment With Confidence

The next step is to begin to vary exposure and learn how your light meter relates (or does not relate) to what you are shooting. On another sunny midday, go back to the same place you shot your first roll, but this time pay attention to your light meter. If you had a shot that you liked the last time but it was blown or too dark, try to recreate it, only this time shift your exposure to achieve the desired result. If the meter reads substantially different than the f11, 125th second exposure, try exposing as it suggests.

• **Take note of your predictions and compare the results.**

• **Learn by changing one variable at a time.**

Frequently you will discover situations where the meter will read the scene much darker than the infrared film sees it.

Again, take your notebook, but in addition to recording your exposures, also record your predictions: How the sky will respond; which trees will white-shift; which clothing will retain its fundamental tones or become incandescent. Paying attention to these details will provide you with a firm understanding of what works for your particular taste.

After these two rolls, shoot any subject that interests you. But remember, the variables (subject; lighting situation; atmospheric conditions; filters) can snowball suddenly. To eliminate confusion while you gain experience, change only one variable at a time.

Variables to try:

- **Exposure: Shoot a scene as your meter suggests, then overexpose and underexpose.**

- **Filters: Shoot the same scene with a red filter and with no filter. Then try an orange filter, or an opaque one.**

- **Subjects: Photograph a person, a tree and a building, all under the same lighting conditions.**

As we continue, you will get a more detailed look at how and why infrared responds the way it does. You will become more confident in predicting the film's response and in deciding how to control that outcome.

First Roll Basics:

- Load and unload only in a darkroom or in a black bag.

- Use only solid black canisters to hold infrared film.

- Keep your black bag and camera clean of dirt and dust.

- Shoot your first roll at a set exposure: f11, 1/125th second with a #25 red filter.

- Take notes and compare them with your results.

- As you shoot more rolls, alter one variable at a time (new filter, different exposure, another time of day) so you can be certain of the affect each element has on the outcome.

Section II:

Advanced Theory

Now that you have successfully shot a roll of infrared, you may be curious as to why some of your subjects exposed the negatives as they did. In exploring the phenomena of infrared exposure, there are three areas to consider:

- light sources

- film sensitivity

- exposure

The following chapters provide insights into these topics. You will learn to discern the characteristics of light sources you will encounter. You will also learn how to read your film's spectral sensitivity curve and predict its reaction to your subject matter, as well as read your film's characteristic curve and determine an ASA setting that will aid you in successfully photographing in infrared.

CHAPTER FOUR

Identifying Light Sources

In photography, we are concerned with two kinds of light: Reflected light and source light. The source light illuminates the scene, but it is the light that is reflected from the scene that exposes film.

• **The reflected light cannot include any wavelengths not found in the source light.**

However, an object can only reflect the wavelengths of light that strike it. Because of this, the same object can change appearance under different types of source lights. For example, a basketball illuminated by an orange light will appear lighter than the same basketball illuminated by a blue light because the ball reflects orange better than blue. The basketball's reflectivity hasn't changed, the light striking it has.

Like visible reflectivity, the infrared reflectivity of any object is a physical property and will not change. Specific objects remain constant in their infrared reflectivity. If you've seen an oak tree print white in your photographs, you can be sure that other oak trees are capable of reflecting infrared in a similar fashion. If an oak tree shows up dark in an infrared photograph, the tree is not different, it is the infrared content of the source light shining on the tree that has changed. Since you cannot see infrared illumination and reflectivity, you must learn how to identify visible source lights and understand their infrared characteristics.

Common Light Sources

Within the visible spectrum, there are many different types of light sources. As a photographer, you might encounter the following natural and man-made sources:

- Sunlight: The light from the sun

- Skylight: The light originating from the sun and reflected by the sky

- Daylight: "Sunlight" plus "skylight" (bluer than sunlight)

- Tungsten light: Artificial light, characterized by a burning filament

- Fluorescent light: Artificial light, created by a phosphor coating that fluoresces when electrically stimulated

- Electronic flash: Artificial light, balanced to imitate daylight

- Industrial HID Lamps: mercury vapor (most shopping malls), metal halide (many sports stadiums), sodium vapor (modern street lamps), produce light by discharging electricity through pressurized gas or vapor

The Language of Light

Talking about light can become confusing, as many terms we use can be misleading if they are taken literally. The term "white light" generally refers to the visible light produced by our sun. As we have already discussed, this light is actually made up of all the colors of the visible spectrum.

Psychologically, our brains perceive this multicolored sunlight as white. However, our eyes can also perceive a tungsten bulb's light as "white" even though the color properties of the two sources are substantially different. Only if we see both lights side by side will we notice that the tungsten light appears orange next to sunlight.

Our ability to discern between colors is based on comparison, not on an absolute scale. Colors can appear different depending on colors nearby, as well as the type of illumination present. Because of this, we use a COLOR TEMPERATURE ▼ scale to provide us with a way of measuring and comparing the true color of different light sources.

▼Color Temperature

The Color Temperature scale is expressed in degrees Kelvin (°K). Do not be mislead by the "temperature" part of the term; thinking in terms of "warm" or "cold" light might confuse you, since the higher the color temperature, the "colder" or bluer the light. 5500°K is referred to as colder light than 3200°K.

Defining a Light Source by its Color Temperature

Each type of source light has two basic variables, the *color* of the light (wavelength, wl) and the *amount* of light. Our light meters measure the volume, but measuring color is a bit more complicated.

To define the exact color temperature of a given light source, we compare it to a BLACK BODY ▼. A black body absorbs all light that strikes it. Since the light energy cannot be reflected, the absorbed energy causes the black body to rise in temperature. At first, as it glows in infrared, we cannot see a change. As it gets hotter, we begin to see a red glow. As the temperature increases, the black body continues to change color, moving through the color spectrum to blue-violet at its hottest. Just as a blue flame is hotter than a yellow one, so a black body glowing blue has a higher color temperature than one glowing yellow. Each color radiated by the black body correlates to a value of color temperature.

Color Temperature as a Tool in Infrared Photography

The basic difficulty with infrared photography is that we cannot see, feel or sense near infrared radiation in any way. Fortunately, there is a bridge that links the visible portion of the spectrum we can sense with the portions we cannot. If we can figure out where on the bridge we are, then we can determine how far the rest of the bridge reaches into the invisible spectrum. This bridge is color temperature, or more specifically, the graph of Color Temperature, called the Spectral Energy Distribution (SED).

The SED shows the relative amounts of energy being radiated by a source at different wavelengths. Every value of color temperature produces a different plot on the SED graph.

At first glance, the entire SED of a light source seems like more information than we need, since we only see the portion of the curves in the visible light region. What is very important to you, as an infrared photographer, is the direction of the curve as it makes its way into the infrared region.

Determining where you stand on the color temperature "bridge" will reveal the infrared character of the light.

You will notice that light of 1000°K and less lies totally within the infrared range and is completely invisible to us. The bridge is not accessible, providing no clues to the amount of infrared light available.

The curve of a light of 2800°K is rising as it enters the infrared zone. You are climbing towards the peak of the bridge. This means there is more infrared light than visible light. As your light meter only detects the visible light, the frame will be overexposed by the region of higher energy if you obey your meter's reading. Every light of 2800°K that you encounter will have similar characteristics.

▼Black Body

A Black Body is a theoretically perfect temperature radiator. The black body emits *no* light when cold. When illuminated by a source light, it reflects *no* light and *no* color. In a laboratory, scientists heat the black body. As the black body changes temperature, it also changes color. Its temperature is measured in degrees Kelvin. The colors of the glowing black body are described by the temperature of the body (°K). Hence, the term *Color Temperature*.

• Color temperature should not be confused with wavelength. Color temperature describes the overall cast of a light source, which is typically composed of hundreds of different wavelengths.

Spectral Energy Distribution (SED)
of Four Color Temperature Readings

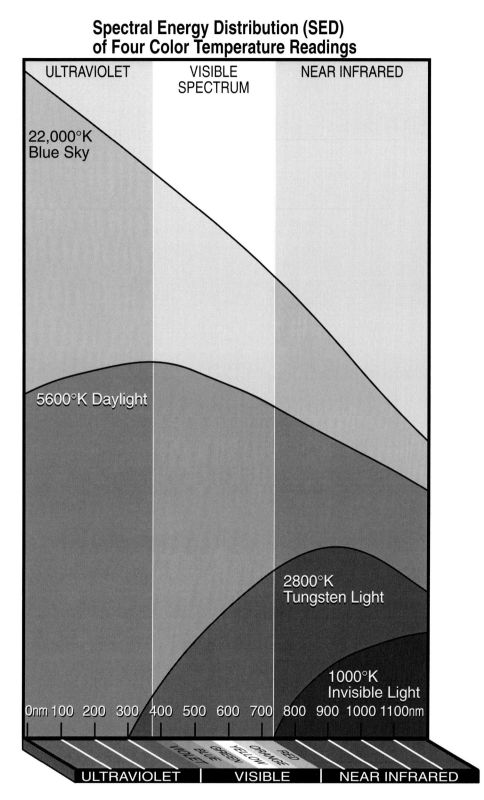

This graph illustrates four color temperatures. The SED at each temperature is continuous, meaning there is a measurable amount of energy at each wavelength along the curve — no dropouts. As the black body temperature rises, the curves move from the invisible and push higher and higher into the blue and ultraviolet regions. At 22,000°K, the color temperature of a blue sky, there is still a significant amount of infrared radiation.

When the source light is bluer, say 5500°K, or daylight, you have passed the center of the bridge and are descending into the infrared region. There is more light behind you in the blue regions than ahead in the infrared region. Here a red filter maintains the infrared look by blocking the high levels of blue light.

At 22000°K, the angle is steep as you are virtually off the other side of the bridge. The blue light here is overwhelming compared to the infrared region. A red filter is a necessity, and an opaque filter will further enhance the infrared look.

Color Temperature Values

The four color temperatures on the SED graph are only a few of the potential values you will encounter. In nature, color temperature is always changing due to environmental factors. The 5500°K standard that we call "daylight" is based on the average color temperature of daylight at noon on a cloudless summer day in Washington, DC. It is highly unlikely that the daylight you are experiencing has the exact same quality.

Atmospheric conditions and time of day can radically change the color temperature of a scene. Overcast skies can send the color temperature skyrocketing to 7000°K and higher. A sunset can shift "daylight" to perhaps 3000°K, a color temperature more commonly created by indoor lighting.

In addition, color temperature also changes with location. Open shade lacks direct sunlight and consequently has a higher color temperature (10,000°K) than the light just a few steps away in full sun (5500°K). In deep shade, the color temperature can be much greater because the illumination of the scene is solely skylight (15,000°K).

Higher elevations are usually devoid of the atmospheric haze commonly found in valleys and coastal regions. This renders the average color temperature closer to 7000°K than the 5500°K "daylight" standard.

Because of the color temperature relationship between visible and invisible light, you can use your eyes and a few rules of thumb to determine the approximate color temperature of the visible light shining on your scene. You can then extrapolate the infrared potential of your photograph.

Studying the SED of a few color temperatures will give you a base from which you can imagine the curves of other color temperatures. This ability to visualize the amount of light at each wavelength for specific color temperatures will aid you in choosing a filter and determining exposure.

The chart shows the average color temperatures of many common light sources. While you can spend an exorbitant amount of money and purchase a color temperature meter to examine the fluctuating colors of your world, you can get along just as well by committing these values to memory and using them to extrapolate your scene's color temperature value before you shoot.

Types of Light and Their Color Temperature Values:

Natural Light Sources:

(color temperature in degrees Kelvin)

Sunlight (mean noon)	5,500
Blue sky	15,000 to 27,000
Open shade	10,000 to 18,000
Hazy Skylight	7,000 to 9,000
Overcast Sky	6,500 to 7,000
Hazy Sunlight	5,700 to 6,000
Average daylight	5,500 to 6,000
Morning or Afternoon Sunlight	5,000 to 5,500
Direct sun at sunrise or sunset	3,000 to 4,500

Artificial Light Sources:

Match flame	1,700
Candle flame	1,850
100-250 watt tungsten	2,600-2,900
500 watt tungsten	2,960
1000 watt quartz halogen	3,200
Photoflood	3,400
HMI lamp	5,600
Xenon	6,000

• **Learn and know the average color temperature values of different lighting conditions. It will give you an edge in estimating infrared exposures.**

This is not a precise system, but it will give you a firm enough understanding to control the outcome of your infrared photography. However there are man-made lights which do not correspond to these smooth color temperature curves. These DISCONTINUOUS SOURCES have totally different characteristics.

Recognizing Continuous and Discontinuous Source Lights

All natural light sources — the sun, fires, candles — are called CONTINUOUS SPECTRUM light sources. This means that their SED is a smooth curve, with light produced at all wavelengths across the photographic spectrum. The brightest wavelengths lend the light its particular color. For example, sunlight will be bluish, and candlelight appears reddish, because peak energies occur at different points in the spectrum.

In the sunlight SED, there is a considerable amount of infrared radiation. However, there is more light in the visible region (the area your light meter responds to). You will expose for the abundant visible light and the infrared will alter the look of your photo, but will not require any shift in exposure.

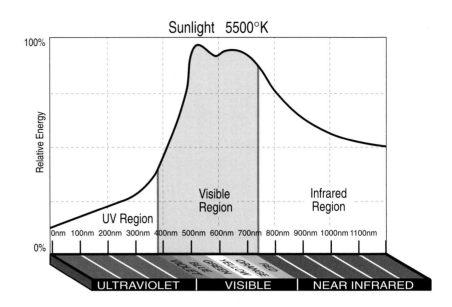

While you study the tungsten SED, note the abundance of radiant energy in the infrared spectrum. We do not see and our light meters do not measure this light, but it is this light that will expose your infrared film. Therefore, you must always be aware of its existence and compensate by stopping down the aperture beyond what your meter reads.

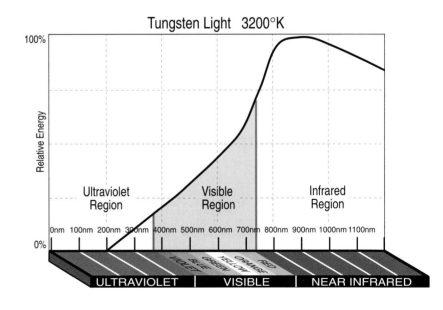

Some artificial sources, such as tungsten halogen lights, are also continuous spectrum sources, producing light (to a greater or lesser degree) in every wavelength across their range. But other types of artificial sources, such as many fluorescents and sodium vapor (street) lights, are DISCONTINUOUS SOURCES. While these may look relatively white, they do not produce energy at every consecutive wavelength, leaving gaps in the light they produce. Furthermore, most fluorescent lamps have been specifically designed to be energy efficient and only produce light in the visible spectrum.

In this SED of a common fluorescent lamp, note the lack of energy in the infrared region (over 700nm).

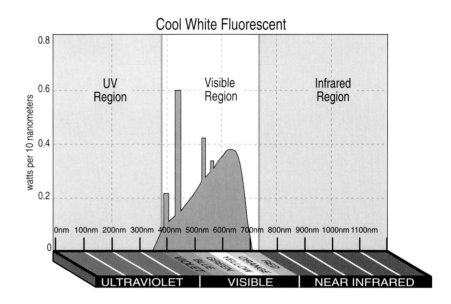

The majority of discontinuous sources produce no energy in the infrared spectrum; any photographs taken under these lights will resemble ordinary black and white photography, with perhaps a little halation around hot spots. This halation is caused solely by the lack of an anti-halation backing on the film, not by an infrared response.

Under both sodium and fluorescent artificial lighting, there will be very little difference between using infrared film or standard black and white film due to the lack of energy in the infrared region.

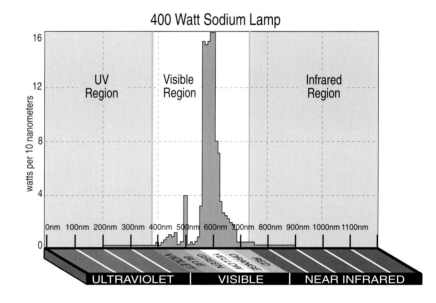

To discern whether a light is a continuous or discontinuous source, ask yourself: Does it burn?

Yes (the sun, candles, filaments in household bulbs), it is <u>Continuous</u>
No (fluorescent, sodium vapor), it is <u>Discontinuous</u>

Now that you have been exposed to the different qualities of common light sources, you can make practical decisions about your photographs before you trip the shutter. To make the most of every frame of infrared, first identify the type of source light and its color temperature, then decide how it affects the reflectivity of the objects in your frame.

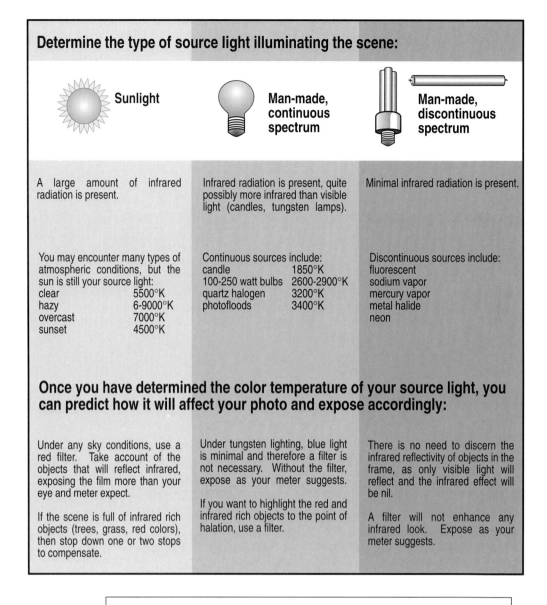

Determine the type of source light illuminating the scene:

Sunlight	Man-made, continuous spectrum	Man-made, discontinuous spectrum
A large amount of infrared radiation is present.	Infrared radiation is present, quite possibly more infrared than visible light (candles, tungsten lamps).	Minimal infrared radiation is present.
You may encounter many types of atmospheric conditions, but the sun is still your source light: clear 5500°K hazy 6-9000°K overcast 7000°K sunset 4500°K	Continuous sources include: candle 1850°K 100-250 watt bulbs 2600-2900°K quartz halogen 3200°K photofloods 3400°K	Discontinuous sources include: fluorescent sodium vapor mercury vapor metal halide neon

Once you have determined the color temperature of your source light, you can predict how it will affect your photo and expose accordingly:

Under any sky conditions, use a red filter. Take account of the objects that will reflect infrared, exposing the film more than your eye and meter expect. If the scene is full of infrared rich objects (trees, grass, red colors), then stop down one or two stops to compensate.	Under tungsten lighting, blue light is minimal and therefore a filter is not necessary. Without the filter, expose as your meter suggests. If you want to highlight the red and infrared rich objects to the point of halation, use a filter.	There is no need to discern the infrared reflectivity of objects in the frame, as only visible light will reflect and the infrared effect will be nil. A filter will not enhance any infrared look. Expose as your meter suggests.

Working with Light Sources:

- Each type of light source radiates unique amounts of each color wavelength.

- The color temperature scale provides a way to define the color of light emitted by a source.

- Sunlight does not maintain a consistent color temperature. Weather, smog, atmosphere, elevation, time of day can alter the color temperature of the sun.

- After identifying the color temperature of a source light, you must consider the scene and what color light is reflecting from the scene.

- Continuous sources emit infrared light.

- Discontinuous sources emit only traces, or no infrared light.

CHAPTER FIVE

Sensitivity and Control

The Film's Sensitivity to Colors

Now you understand how to predict the color of light produced by your source and how some of this light reflects off objects in the scene and onto your film. The next step involves a closer study of your infrared film.

- Which colors expose infrared film?

- How much does each color expose infrared film?

To answer these questions, we must examine the SPECTRAL SENSITIVITY CURVE for infrared film. This graph shows how sensitive the film is to specific wavelengths. The amplitude (height) of each point on the curve defines how much an equal amount of each wavelength or color will expose the film. An ideal black and white film would have a perfectly flat spectral sensitivity curve. This would guarantee an accurate tonal translation of a color scene.

However, the sensitivity of the human eye is not flat. The eye's sensitivity peaks in the green region and falls off in both directions towards ultraviolet and infrared. Designing a black and white film includes consideration of both true representation of colors in black and white tones and human perception of the tonality of colors.

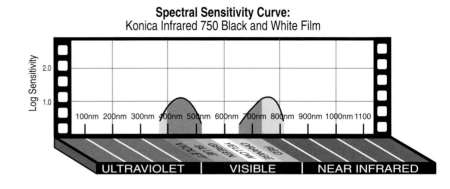

This graph reveals that when a violet and an infrared wavelength of equal intensity strike the film, they will expose equally. A green wavelength will appear black in the print.

Looking at the Spectral Sensitivity Curve for the Konica Infrared you will notice that the curve is far from a straight line. This film is sensitive in two specific areas and does not respond at all in the center of the visible spectrum. The Konica is basically an orthochromatic (blue sensitive) film, coupled with an infrared sensitive emulsion.

In comparison, the curve of the Kodak infrared negative is uninterrupted. This film's sensitivity is erratic in the region from ultraviolet to green and relatively flat from the yellow into the infrared.

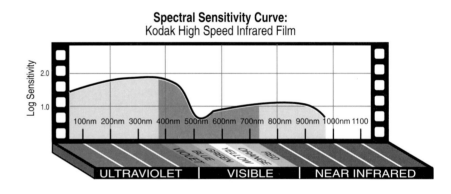

This graph reveals that if a violet, a green and an orange wavelength of equal intensity strike the film, the violet will expose nearly twice as much as the orange. In the print, the violet will appear much lighter. The green will print darker than any other color.

Both the Kodak and the Konica infrared curves have two peaks of sensitivity and dip in the green region. This type of response, almost the exact opposite of human perception, is unique to infrared films.

Utilizing Filters to Alter Sensitivity

A study of the Kodak spectral sensitivity curve reveals it is more sensitive to the blue portion of the visible spectrum than it is to the infrared wavelengths. This means that in an unfiltered infrared photograph, the ultraviolet and visible light will dominate the exposure, burying the infrared response.

• **Kodak infrared film is more sensitive to visible light than to infrared light.**

When we look at an array of pure colors, our eyes tell us that violet is dark, blue is lighter, and green is lighter still. If we photographed that same array of pure colors with the Kodak High Speed Infrared film, the reverse would result: Violet lightest, then blue, and green would appear almost black.

Exposing *Kodak High Speed Infrared Film* With No Filter

The infrared film's spectral sensitivity renders sunlight in an uneven pattern.

Here, superimposed on the Spectral Sensitivity Curve, is the range of black and white values the film would produce when exposed by a full array of pure colors at equal intensity. Where the curve dips lowest (least sensitive), the tones are darkest. Where the curve is highest (most sensitive) the same amount of light produces a much brighter tone.

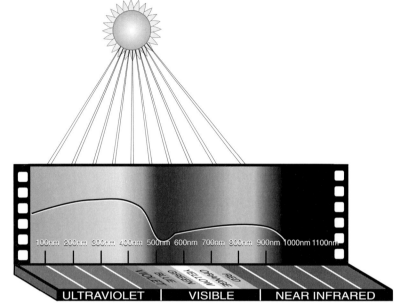

In order to correct for the lopsided response of black and white infrared film, we pull filters from our arsenal and put them to work. A filter can eliminate exposure from the ultraviolet, blue, and green regions, restricting the film's response to the area where it has an even sensitivity.

Exposing *Kodak High Speed Infrared Film* With a #15 Orange Filter

When photographing the array of pure colors through a #15 orange filter, everything from ultraviolet to green will not expose. The unaffected section of the spectral sensitivity curve is relatively flat so the remaining portion of the spectrum will be accurately translated into grey tones, gradating evenly from light to dark.

100nm 200nm 300nm 400nm 500nm 600nm 700nm 800nm 900nm 1000nm 1100nm

ULTRAVIOLET | VISIBLE | NEAR INFRARED

• Filters can block visible light and still transmit infrared light.

Depending on how much of the visible spectrum you want to include in your image, you have a choice of the yellow #8, orange #15, red #25, and opaque #87, #88A, and #87C filters. A #25 deep red filter blocks the ultraviolet and most of the visible wavelengths. Opaque infrared filters block the ultraviolet and all of the visible wavelengths. Both filters still transmit infrared light to the negative. You may also want to experiment with the look of unfiltered infrared. This will not give you an "infrared" photograph, nor will it represent the scene as perceived by the human eye, but it may be an appropriate style for certain subjects.

• Filters differ in how much visible light they block.

When choosing a filter, consider the colors of your subject. Predict the effect each filter will have on your subject, keeping in mind that most colors are made up of many different wavelengths.

- A purple shirt might reflect both blue wavelengths and red wavelengths, not just violet wavelengths. If you photographed the shirt through a red filter, the red wavelengths would expose the film. If the purple shirt reflected only violet wavelengths, no light would reach the film through the red filter.

- A clear, haze-free blue sky reflects no infrared light. When photographed through an opaque infrared filter, this sky will expose purely black.

Choose your filter based on the range of colors within the scene versus the range of tones you want represented in the photograph.

Analyzing a Filter's Transmission Characteristics

A Spectrophotometric Curve shows how much light a filter transmits at each wavelength. There are "broad-band" filters and "sharp-cutting" filters. The "broad-band" type have a softer curve; the transition between the wavelengths that are transmitted and those that are absorbed is gradual. The "sharp-cutting" have an abrupt cut off between those wavelengths that transmit and those that are absorbed. These sharp-cutting type filters are most useful in infrared photography.

The yellow #8 and red #25 filters both absorb ultraviolet and blue light. The yellow filter moderately underexposes the sky, providing a tonal representation close to our own vision. The red filter heavily underexposes the sky, creating a less naturalistic, more dramatic look.

Blocking most of a scene's visible light may seem drastic, but most objects reflect light in the infrared as well as visible spectrums. Only by stripping away visible light with filters can we reveal the scene's hidden infrared characteristics to the film.

The yellow #8 filter is a "sharp cutting" type filter. Using this particular filter, we eliminate virtually all exposure from any wavelength less than 450nm (UV, violets and blues).

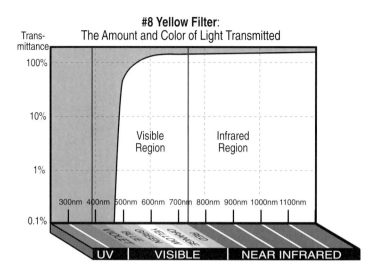

#8 Yellow Filter:
The Amount and Color of Light Transmitted

The #25 red filter is also "sharp cutting" eliminating all exposure from any wavelength less than 600nm (UV, violets, blues and greens).

#25 Red Filter:
The Amount and Color of Light Transmitted

The #87 filter is opaque, meaning no light in the visible spectrum passes through to reach the film. You will not be able to see light through this filter.

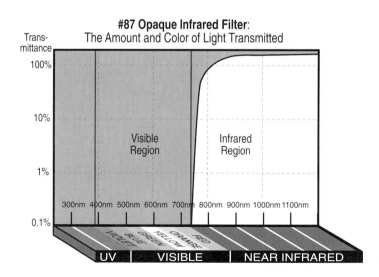

#87 Opaque Infrared Filter:
The Amount and Color of Light Transmitted

Choosing the Right Filter

• **Filters block the visible light that can overwhelm infrared images.**

To my eye, neither the yellow #8 nor the orange #15 filters provide enough filtration to properly expose infrared negatives. The best all-purpose filter is the red Wratten #25 (or equivalent). This gives you maximum infrared filtration with an acceptable exposure loss of two stops (see filter factor on page 52), and allows the photographer to look through the lens. By comparison, the opaque #87 filter requires opening up the iris by three stops. This requires slow shutter speeds and fixed compositions, making this filter impractical for many subjects. For buildings, landscapes, or still lifes, the opaque can be quite rewarding, but for versatility, stick with the red.

Infrared

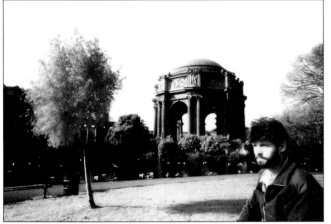

no filter

T Max 100 ASA

no filter

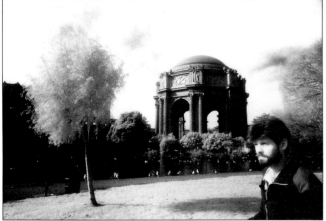

#8 yellow

#8 yellow

Infrared

T Max 100 ASA

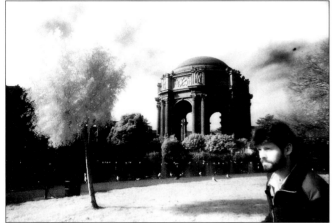

#15 orange

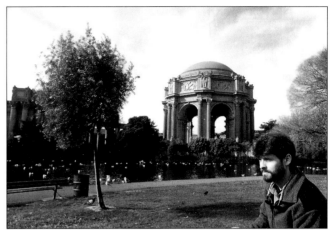

#15 orange

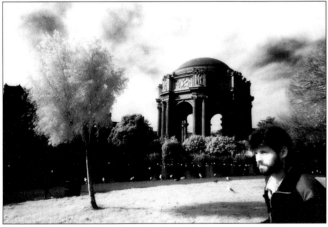

#25 red

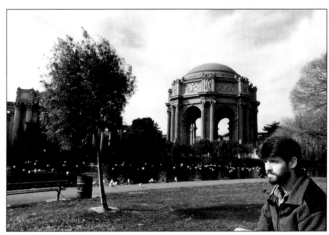

#25 red

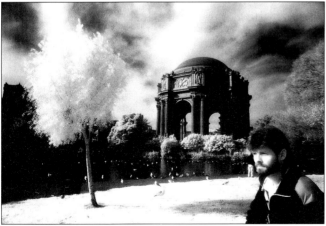

#87 opaque

When No Filter is the Right Choice

• **No filter is required under source lights of 3200°K.**

There are situations when the use of a filter is not necessary. This occurs when a subject is illuminated by a source light rich in infrared radiation and deficient in the blue wavelength range. These include tungsten light, quartz halogen light (3200°K), fire or candlelight, and household incandescent bulbs.

The combination of 3200°K light and infrared film is particularly conducive to photographing people. The infrared-rich light maximizes the smoothing and halating qualities of the infrared film to create luminous, flattering portraits.

It is not necessary that you remove your red filter under these lighting conditions. A filter will brighten the infrared reflective objects in the frame, but it will also block two stops of light that could be padding your depth of field, and cause your meter to give a false low light reading. If you shoot with a red filter under tungsten light, stop down your aperture at least one stop.

There are times when sunlight is made up of warm red wavelengths. About an hour before sunset, the color temperature of sunlight begins to fall rapidly from 5500°K to below 3000°K when the sun finally sets. At this time, the sunlight acts very much like tungsten lighting. If your subject is lit by the setting sun and you have no sky in your frame, you will be safe removing the red filter from your lens. At sunset there is more infrared radiation than visible light, so be cautious when considering your meter reading. The visible light reading can be as much as two stops lower than the visible and infrared light combined. Take care not to overexpose.

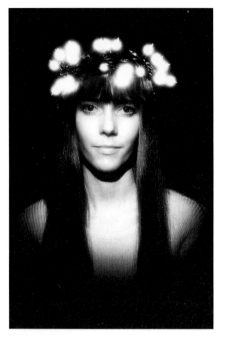

This portrait was exposed under 3200°K tungsten lights with no filter on the camera. The lights in the frame radiate a lot of infrared light and therefore halate.

Understanding film sensitivity and controlling it:

• The Spectral Sensitivity Curve shows how sensitive a film is at each wavelength of light.

• Infrared films are highly sensitive to blues and moderately sensitive to reds. They have very little response to greens.

• Filters can equalize a film's varying sensitivities to different colors.

• Use sharp cutting filters for the correction needed in infrared.

• Filter choice is based on subject matter and desired result.

• The all-purpose filter for pictorial uses is a #25 red.

• No filter is necessary under tungsten light or any reddish light source of 3200°K or less.

CHAPTER SIX

Exposing the Negative

The characteristics of infrared film allow you to explore different styles, depending on how you expose the negative. The typical grainy, highly halated, "blown" infrared photograph is only one of three distinct photographic looks. With the right handling, the infrared negative can combine the image structure of traditional black and white with infrared halation. Exposed another way, it will result in a high contrast, fine-grained print. In order to explore these varying styles, it helps to know how infrared film differs from other films, and how these differences make infrared a singular photographic medium.

Film's Sensitivity to Light

All films are sensitive to light. The differences in how each particular film responds to light allows each film to produce a characteristic look. We can see these characteristics in their pure form with a SENSITOMETRIC CURVE.

A sensitometric curve graphs a film's response to exposure, defining the amount of light required to create an image on the negative. In addition to disclosing the ASA/ISO ▼, the graph tells you two things:

- The film's LATITUDE — the range of f-stops that will expose properly on the negative

- The film's contrast, which can sometimes be altered during processing

Reading the Film's Characteristic Curve

The sensitometric curve for a specific film is called a CHARACTERISTIC CURVE. To read a characteristic curve, imagine that the light from the scene (represented in f-stops at the bottom of the graph) hits the curve and is reflected onto the negative (the left side of the graph). Zero density on the negative will reproduce as black in the print, while 100% negative density will be white in the print.

On any characteristic curve, the even spacing of the exposures (bottom of graph) does not change. It is the curve that reveals how the film responds. The exposures are reflected from the bottom of the graph through the curve and onto the left side of the graph, illustrating how each level of exposure will be translated to density on the negative.

The left side of the graph shows how exposures made in the middle of the curve produce evenly spaced densities on the negative. Exposures made

**▼ASA/ISO
(American Standards Association/
International Standardization
Organization)**

Each film requires a certain amount of light to achieve exposure above the film base plus fog level. This light will produce changes in density discernible by eye and thus a usable image. Greater amounts of light yield greater densities up to a maximum for each film. This area of exposure is graphed as a film's characteristic curve.

A film's ASA corresponds to the amount of light needed to expose at the center of the straight-line portion of the characteristic curve. The amount of light reaching the film is controlled by exposure time and lens aperture.

The ASA speed of a film is an arithmetic scale. Each time the ASA doubles, the required exposure for a given scene is reduced by one stop. The entire scale is divided into intervals equivalent to one-third stop exposure changes, so that every third index number represents a whole stop, thus:

50 64 80 **100** 125 160 **200** 250 320 **400 500**

When a photograph is taken, different exposures in the scene hit the film's emulsion and cause the negative to respond in different and specific amounts, creating a density level for each degree of exposure. Each density will in turn reproduce as a separate grey tone in the print.

Several different exposures in the toe region are compressed, meaning they will all reproduce as the same tone in the print. The same occurs in the shoulder region; separate exposures will reproduce as the same color white in the print.

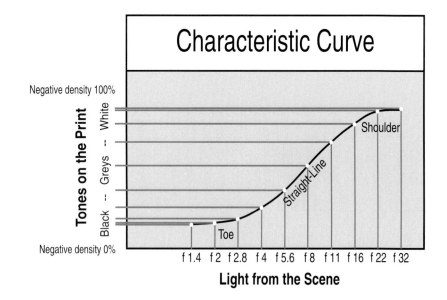

on the two ends of the curve result in negative densities that are much closer together. We define these three areas of the characteristic curve as the STRAIGHT-LINE, the TOE and the SHOULDER.

Straight-line

- **The ASA/ISO suggested by the manufacturer of a film is a guide that places exposure within the straight-line portion of a film's characteristic curve.**

On the straight-line portion an increase in exposure creates a proportional increase in density. This means that if an object in your scene is one stop brighter than another object, it will also appear one stop brighter in your print. Photos exposed in the straight-line portion accurately reproduce the range of tones in the scene, rendering the subject with correct contrast.

The length of the straight line portion defines the latitude of a film. If the straight-line portion extends five f-stops along the bottom axis of the graph, the latitude of that film is five stops.

Toe

The toe is the region of underexposure. Exposure within the toe results in negative densities that are compressed. An object one stop darker than another will not appear one stop darker in the photo. Two separate values might even reproduce as an identical dark tone. This is not an accurate representation of the scene. Additionally, as exposures are made deeper in the toe region, their densities on the negative are hardly above the level of the base fog. At this point, the resulting print is murky and unusable.

Shoulder

The shoulder is the area of overexposure. As with the toe, exposures in this region are compressed. An object one stop brighter than another will reproduce less than one stop brighter. The degree of inequality increases until finally all exposures above a specific value will reproduce as pure white.

Characteristic Curves of Kodak Plus-X, Kodak Infrared and Konica Infrared

Comparing the characteristic curves of different types of films reveals how each film responds differently to exposure. In order to understand why infrared behaves so unusually, we will compare it to a familiar and predictable black and white film, such as Plus-X.

The characteristic curve of the Kodak Plus-X (a visible light black and white film) has an almost perfect 45° angle. This means that equivalent exposure changes in the scene are reproduced as equivalent changes in density. The straight line portion shows a substantial range of latitude, almost 9 f-stops. By comparison, the Kodak Infrared negative has only about 3 f-stops of latitude and the angle of its straight line portion is much steeper than the Plus-X. The Konica curve is steeper still. This reveals that both these infrared films produce higher contrast images than Plus-X.

45

A value of 1 on the log exposure axis is equal to 3 stops of exposure.

The Plus-X has a wide latitude of almost 9 f-stops, as its straight-line portion reaches from log -1.5 to 1.00.

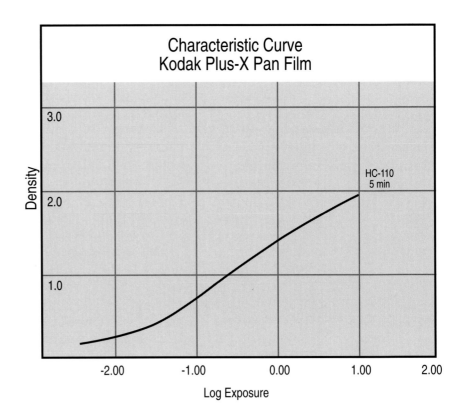

In addition to illustrating the latitude and contrast, the characteristic curve shows how a film will respond when over- or underexposed. The nature of the curve in the shoulder and toe regions provides clues to a film's pictorial character.

On the characteristic curve of the Plus-X, the extended straight-line portion and abrupt cut-off of both the shoulder and toe shows that no matter where on the curve the exposure is placed, the image structure will not change significantly. Underexposure will result in a negative unwilling to reveal detail in a print obscured by emulsion fog. Overexposure will produce a washed-out print.

The curves of both Kodak and Konica show infrared films that behave completely different. Note that when developed in D-76, Kodak Infrared's toe and shoulder regions are virtually as long as the straight-line portion. Both toe and shoulder regions feather off slowly, allowing a few more stops of exposure. In contrast, regardless of what the developer used, the Konica shoulder cuts off sharply and the toe exhibits a more abrupt transition than the Kodak.

Although the two infrared films have approximately the same latitude, these differences in shoulder and toe regions cause their resulting photographs to be distinctly different. If a frame is overexposed, the Konica abruptly achieves maximum density, and no detail is recorded. Conversely, the Kodak's extended shoulder responds to overexposure by recording the two additional stops falling within the shoulder at nearly equivalent densities, but still with separation and detail. Given the difficulty of determining exact exposure in infrared, using Konica reduces your acceptable margin of error.

The response of the Kodak infrared negative can be altered by development in different chemicals:

The D-76 results in a medium contrast negative, ensuring the widest latitude and the lowest contrast for pictorial uses.

The D-19 can be used to heighten contrast, resulting in a negative similar to the Konica infrared negative.

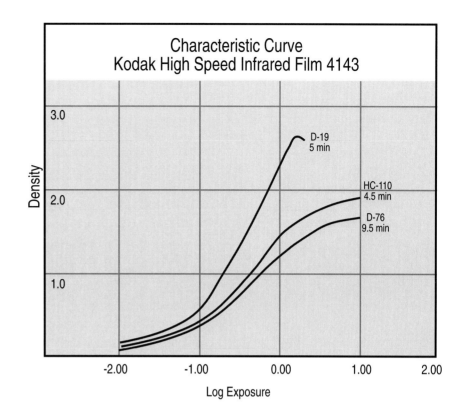

The steep angle of the Konica infrared curve clues you in to the narrow latitude and high contrast inherent in the film.

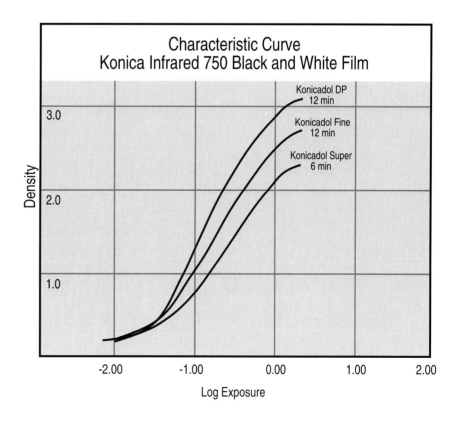

Using the Characteristic Curve to Make Creative Decisions

All films respond best when exposed in the straight-line portion. Photos produced in this way are considered properly exposed. But using "proper exposure" is not always the best way to achieve the final effect you desire. Variances in infrared exposure produce such distinct changes in image structure and the resultant photograph, that "proper exposure" becomes a relative term.

• **Kodak Infrared has three different areas of "proper exposure."**

Unlike any other film, the extended shoulder and toe of the Kodak infrared effectively gives you three distinct areas of exposure, each with unique qualities. By placing your exposure within the shoulder, toe or straight-line portion, you can give your work one of three distinct looks.

(1) Subtle Black and White with Infrared Overtones

Exposing in the straight-line region will result in a moderately grainy print. Due to the narrow latitude of the film, the center values of the scene will be rendered accurately; and detail in the brightest and darkest areas will remain intact due to the gradual roll-off of the Kodak infrared's shoulder and toe. This choice produces a sharper image closer to ordinary black and white, but without losing the overtones and highlights characteristic of overtly infrared photos.

A frame of Kodak infrared exposed in the straight-line region will render the scene in an array of grey tones that correspond to the array of tones in the scene.

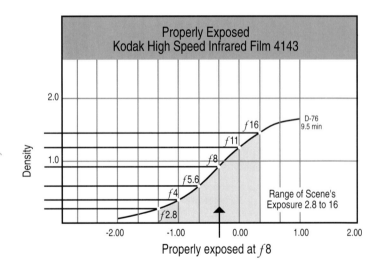

The Kodak Infrared has a latitude of three stops. If your scene contains values of *f*2.8 to *f*16 and you expose at *f*8, everything between *f*5.6 and *f*11 would be on the straight-line portion. The *f*2.8 and *f*4 values would fall within the toe and the *f*16 would be in the shoulder region.

(2) Dramatic Hard Contrast

Exposures in the toe compress the darker values of the scene. Few mid-greys and heavy blacks create a higher contrast. With the higher contrast, the apparent grain lessens. The brightest objects in the scene expose the

straight-line portion, and when printed can be held back to render white. The high contrast and minimal grain combines a hard look with unexpectedly soft tones and halation of very bright objects.

An underexposed frame of Kodak infrared will not render the array of darker tones in the scene in an equivalent fashion. The darker tones are compressed.

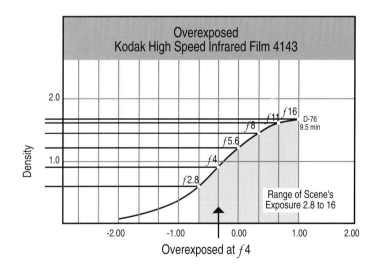

In the same scene as above, if you exposed at ƒ16, only values of ƒ16 or ƒ11 would be on the straight-line, and the rest of the scene -- ƒ2.8 to ƒ8 -- would expose within the toe region.

(3) Soft Typical Infrared

Exposures in the shoulder region cause the values of the scene to compress, this time towards the center values. Strong blacks will disappear, replaced with a narrow range of very grainy mid-tones. Even the darkest objects will only print as mid-grey. In attempting to print detail in the dark areas, the whites will also expose grey. This is the typical "blown" infrared photograph, with glowing trees and surreal vistas.

An overexposed frame of Kodak infrared will not render the array of brighter tones in an equivalent fashion. The brighter tones are compressed.

If your scene contains values of ƒ2.8 to ƒ16 and you expose at ƒ4, only values of ƒ2.8, ƒ4 and ƒ5.6 would be on the straight-line portion. The ƒ8, ƒ11 and ƒ16 values would fall within the shoulder region.

The Creative Decision

Looking at the photos from your first roll, you will discover that you have shots exposed on different portions of the characteristic curve. Try to identify which frames are exposed in the shoulder, straight-line, and toe regions. Once you decide which portion of the curve produces your favorite style of image, you will need a standard guide to locate that area of the curve: ASA/ISO.

Choosing an ASA/ISO Rating

The manufacturers do not suggest a specific ASA/ISO rating for infrared film. This is understandable since the source light and subject matter are seldom constant. Every type of light emits a unique amount of infrared and every object has a unique ability to reflect that infrared light.

It is widely accepted that the only way to guarantee the right exposure is to bracket your exposures, using three or four frames for every shot you attempt. This can become cost and time prohibitive and is not necessary. I suggest you start with ASA 200, using a #25 red filter. This setting allows you to meter the light through the lens (and filter) with your camera's reflected light meter. If you are using an incident meter, set your meter's ASA at 50 (the proper ASA with the filter factor).

• **Use your meter readings as a suggestion, not a decision.**

Remember, the ASA/ISO you choose is merely a starting point, a tool with which to make educated guesses about the scene you are photographing. Your meter tells you how much visible light is available. It is up to you to examine the character of the source light and evaluate its infrared content relative to the visible light.

Setting the ASA at 200 will keep you in the straight-line portion in most situations. Keeping the ASA constant, you can alter the look of your subjects by changing exposure. If you want a grainy look, overexpose by two stops. If you want a fine-grained, contrasty image, underexpose by two stops. By changing your exposure in this way, you are effectively altering the ASA setting for one specific photo.

Determine the ASA that gives you a properly exposed negative by testing with your camera and metering system. If you find your exposures are consistently overexposed, try your next roll at ASA 400; if all your exposures are underexposed, try ASA 100.

If you are using an automatic camera, find out which ASA your camera uses for films without DX coding. Then each time you shoot, adjust your exposure to compensate for this default ASA. For example, if your camera sets the internal meter to ASA 100, and you wish to expose for ASA 200, stop down one f-stop from the meter's suggested exposure.

• **Bracketing is a last resort.**

As you shoot more rolls, you will grow confident about your exposures. Only in unusual situations or with unfamiliar subjects might you protect yourself with some bracketed exposures.

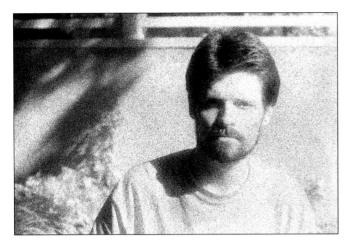

ASA 50, Shoulder region, low contrast.

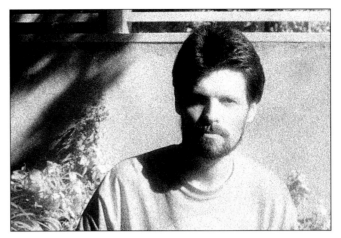

ASA100, Straight-line portion.

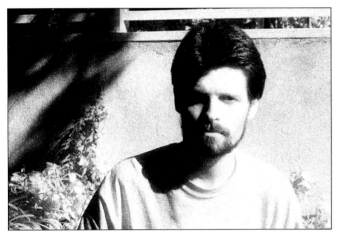

ASA 200, Straight-line portion.

ASA400, Toe region, high contrast.

Understanding the Limits of Your Light Meter

• **Your light meter does not read infrared light.**

Your light meter, no matter the make or model, does not respond to infrared radiation. However, because there is a relationship between visible and infrared light, we can use our meters to make educated guesses about exposure. Before you expose, you must take into account the filter you are using (how much visible light will reach the film), the relative strength or weakness of your source light as a producer of infrared, and the infrared reflectivity of your subject.

Your light meter partially takes into account the effect of the filter and completely ignores the other two factors. What it reads as the proper exposure in the straight-line portion could very easily be within the shoulder of the curve.

To compensate, face the scene and:

• Take a meter reading.

• Identify your light source and estimate the amount of infrared emissions. Remember that sunsets, smoggy days, and incandescent lights are rich in infrared.

- Identify those objects in the scene that will reflect a large amount of infrared. From your first roll, you know that green grass, leafy trees, people, red objects and clothing are particularly reflective infrared subjects.

- If the scene is filled with infrared reflective objects: 1) stop down one stop to achieve a more controlled, normal exposure; or 2) expose as the meter suggests to achieve a luminous and grainy image.

Put your choice of filter on your lens and meter through it. If you are more comfortable with a handheld incident meter, then make sure you compensate for the FILTER FACTOR ▼ before adjusting your exposure. With any one of the opaque infrared filters you must use a handheld meter, or read the light before the filter is in place.

If you are shooting in a tungsten light situation, remove the red filter from your lens and shoot according to your light meter. Using the red filter with light that is infrared rich will fool the meter into indicating a setting that will cause overexposure. Use your meter as you would normally, then make adjustments for any obvious infrared-rich anomalies.

▼Filter Factor

Since a filter absorbs some of the light passing through it, you must compensate for the light loss. A filter factor tells you how many stops you must open the aperture to achieve the same exposure with the filter as without. A filter factor of 2 means that you must open the aperture one stop. Exposure must be increased one stop each time the filter factor doubles.

The factor is a property of the filter and is listed by the manufacturer. In some cases separate factors are given for daylight and tungsten light. A red filter will allow more light through under tungsten than in daylight. Therefore, the filter factor of a red #25 filter is higher under bluish light and lower under red-rich light.

A meter reading taken through a filter will automatically include the filter factor, as the meter is reading the same light that will reach the film.

Exposure guidelines:

- The Kodak infrared negative can be successfully exposed at several different ASA/ISOs:

 ASA 400 for more contrast, less grain

 ASA 200 for medium grain and contrast

 ASA 100 for grainy, low contrast images

- ASA/ISO 50 is a good place to start with the Konica infrared.

- Use your light meter reading as a guide, and alter exposure depending on your inventory of the scene.

Section III:

Making the Theory Work For You

Now that you have a better understanding of infrared light and how it is captured on infrared-sensitive film, it is time to consider specific subject matter and techniques.

In Chapter Seven we will cover general guidelines for different subjects: people; buildings; landscapes; and night scenes. Then in Chapter Eight we will examine specific photographs which illustrate all we have covered.

CHAPTER SEVEN

How to Best Photograph:

People

Infrared film has a reputation for producing strange portraits, sometimes completely altering a person's appearance. However, infrared also has beneficial effects for portraiture. Learning to maximize the advantages and minimize the difficulties is simply a matter of experience.

Sunlit infrared snapshots are usually pleasing because of the friendly effect of the film on the subject's skin. It produces remarkably even skin tones, softening lines and wrinkles.

For formal portraits, you must be careful because a subject's skin can appear translucent, or facial hair can become transparent, causing a face to take on a totally different shape. Depending on the individual, a freshly shaven man may appear to have razor stubble, while another who is bearded will seem to have very little facial hair. Eyebrows may also suffer this transformation, vanishing entirely on some people. These variables are what make infrared portraiture an advanced skill. Therefore, if you are looking for a representational photograph of a person, be prepared to experiment.

Byron and Gabriel: In this portrait, a single tungsten halogen light from the side created high contrast and glowing skin tones. The resulting combination of thick blacks and luminous whites creates a captivatingly silky look. Exposure was on the toe of the negative, minimizing the grain and heightening the contrast.

Portraits under tungsten illumination or sunlight

In General:

- No base make-up is needed. Infrared evens skin tone, lightens freckles, and softens lines and wrinkles.

- With Konica infrared film, skin is extremely transparent and may show veins, undermining the film's usefulness for portraits.

- Sunglasses: Even the darkest and most UV opaque can be transparent in infrared. The angle of the light is important in this situation. If the source light is head-on or overhead and reaching the subject's eyes, they will be visible through the lenses of the glasses. If the subject is under a crosslight and the light is not reaching their eyes, chances are they will remain dark.

- Both high grain and low grain produce a flattering effect.

For olive-skinned subjects:

- Hair, beards, eyebrows and lashes expose consistently.

- Due to thick, dark facial hair, razor stubble is apt to show through the skin.

- Brown eyes can expose transparent when in direct light.

For fair-skinned subjects:

- Blond, red and light brown hair, beards, eyebrows and eyelashes will diminish and sometimes disappear.

- Freckles blend into the skin.

- In order to keep facial features from disappearing, use dark mascara, eyebrow pencil, and lipstick (not red) on fair-haired subjects. Red lipsticks will overexpose and turn white, the opposite of the desired effect.

Portrait of Karin: This image was lit with tungsten halogen, but here a fill light and backlight soften the shadows and create reflections on the hair. Exposure is on the shoulder of the negative, creating a grainy image with a limited range of tones.

Architecture

The same variability that makes portraiture difficult becomes an asset when photographing buildings. Many times you can improve the appearance of a building, giving life to an otherwise static subject.

Outdoors, you must plan your photographs according to the position of the sun. Morning light can provide you with a beautiful crosslight, a strong frontlight or backlight. At midday, the sun high overhead creates toplight. Mid-morning and mid-afternoon, depending on the orientation of the structure, can evenly illuminate the facade, or provide shadows that accentuate the shape of the building. And as the day comes to an end, the crosslight, backlight and frontlight options return. Look at the building, study its shape, facade details and positioning on the landscape. Choose the light that will emphasize these features.

Crosslight will accentuate any texture in a building's facade, from columns down to tiny detailed friezes. Make sure you are patient and wait for the sun to achieve the ideal angle to highlight any important features.

Toplight will illuminate a structure evenly. With regular black and white films, midday is not the ideal time to photograph anything, as the shadows are harsh and the light is flat. However, the differing materials found in a building's facade may reflect infrared light, and certainly any surrounding elements in the landscape will provide a look unique to infrared. This is also the easiest time of day to make an accurate guess at the color temperature of the light.

Hotel de Ville, Paris: Late in the day, the sun's crosslight on the facade of the building accentuates all details. In addition, the frontal angle of the sun makes the building more brilliant than either the plaza or the sky.

Don't forget to consider the sky and weather conditions. A clear blue sky will photograph a solid dark tone. Clouds can help to liven up a composition, contrasting their organic quality with the ordered lines of a structure.

Backlight will mask any detail in the building, representing its shape in an eerie darkness surrounded by overwhelming halation from the sun. A successful backlight photo is tricky to accomplish, as any surrounding objects and foliage will also photograph dark, and their shapes will be incorporated into the overall silhouette of the building.

Frontlight will isolate the structure, emphasizing its overall shape. The building will photograph very brightly, framed by a darkened sky and long shadows. Any surrounding foliage will also be frontlit, and therefore expose white.

Since most architectural detail is located on the vertical areas of the structure, shoot when the sun is low enough to give them relief with shadows. Think about the sky, clouds, the surrounding foliage. Try to guess which will turn white, which won't, and design your composition based on your predictions.

Landscapes

With films sensitive only to visible light, we are typically limited to shooting landscapes early or late in the day, when the golden hours of crosslight improve contrast and add depth to the image with richly textured shadows. Midday light tends to be either harsh or hazy, and photos taken at this time suffer from either excessive contrast or a washed-out look.

With infrared film you can shoot any hour and get striking images. Even under the harsh midday sun, infrared film can uncover unexpected gradations of tonality that are not apparent to our eyes or other films. Infrared film also works nicely during the hours of crosslight. But these different conditions will produce substantially different images:

Bodie House: Midday light exaggerates the warped geometry of this structure with dramatic areas of deep shadow. Old wood has a remarkable variety of infrared tones, quite invisible to the eye.

- •**Midday** is the easiest time of day to shoot infrared. The sunlight is rich in infrared and equally illuminates all of the scene. Under these conditions, you can be sure of capturing an all-inclusive infrared record of your scene.

- •**At the beginning or end of the day**, the severe crosslight will increase the contrast in your image, sometimes reducing a complex scene to graphic elements. These high contrast images will take more effort in the darkroom to print, as you need to equalize the imbalance between land and sky exposures. Here, it is particularly important to contemplate composition, and maintain graphic balance in the image.

View of Delicate Arch: When the sun is high, the even quality of the light tends to flatten the scene in visible black and white photos. At midday, using infrared sensitive film exaggerates the tonal range of the scene, adding depth.

Take care not to use the sun in your photo, or create a severe backlight situation, unless you desire an eerie effect. If the sun is in the shot or just outside the frame, it will be impossible to bring out detail in any foreground elements. Work in the darkroom won't provide any help. The infrared negative lacks the latitude to represent both extreme highlights and deep shade. There is just not enough information on the negative to render detail in the shadows.

Night Scenes

For most applications, using infrared at night is no different from using any black and white film. Night-time illumination is generally from low-level, discontinuous sources such as sodium vapor street lights, or neon-type signs. These lights emit no infrared radiation and therefore will render your photograph similar to a normal black and white photo. The only "infrared" effect is halation of very bright objects such as light fixtures within the frame.

A common misunderstanding of infrared film is that it can photograph a subject in the dark. This is not entirely true. The film can only record the light that is reflected by the subject. In total darkness, the film would not be exposed. However, darkness is a relative term. A scene can be illuminated by infrared light only, thus appearing totally dark to the human eye, but quite bright to an infrared sensitive film.

To make photographs "in the dark," a gel-type infrared opaque filter is placed in front of a tungsten light source. This makes the room dark to our eyes, but still transmits the invisible infrared radiation produced by the tungsten source. Do this, and you can photograph people or animals in situations where they believe it is dark.

Brendan: Here, in a scene illuminated by a neon sign and a street light outside of the frame, there are no recognizable infrared effects except the soft halation. This photo would appear almost identical if taken with regular black and white film.

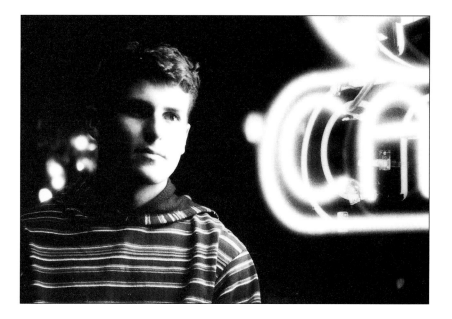

CHAPTER EIGHT

Examples of Putting Theory to Work

At first, infrared photography can be overwhelming, as you realize each new scene and every new lighting situation raises questions you do not yet have the experience to answer. The following examples will provide you with a store of experience, and you won't have to expose a single roll of film.

Comparing Kodak and Konica

The choice between the Kodak High Speed Infrared and the Konica 750nm will affect the outcome of your photos.

Konica is a high contrast film. In a shady area where the scene is low contrast, it will provide a harder look. Konica's erratic spectral sensitivity shows that there is no response to green or yellow light. Because of this, an orange filter will create the same look as a red filter without losing an extra stop of exposure. This film stock's finer grain and anti-halation backing reduce the glowing halos on bright subjects.

Kodak can produce varying levels of contrast by altering exposure. Its sensitivity to the entire photographic spectrum allows you to use filters to create a wide variety of looks. Each filter in the series from UV/Haze to #87 will create increasing amounts of contrast. The lack of an anti-halation backing allows the film to spectacularly halate, even when exposed for finer grained images.

These two photos were shot at the same time, with the same lens and filter configuration. The obvious differences are due to the variations in each film's sensitivity and contrast. The Kodak (above) has many more grey tones than the Konica (below), while the Konica is much finer grained.

What Lenses are Best for Infrared?

A large part of the infrared "look" comes from the range of unique tonal shifts obtained by photographing infrared light. In order to include a wide variety of objects from foreground details to the inimitable infrared sky, a wide angle lens is a good choice for infrared photography.

The large depth of field common to a wide angle lens will simplify focusing problems. At f11, a 35mm lens with focus set at 15 feet will hold everything from 7 feet to infinity in focus. A 24mm lens set at 8 feet and f11 will hold everything from 4 feet to infinity in focus.

However, when using lenses 24mm and wider, you are frequently apt to have foreground objects very close to the lens. This requires that you use the highest f-stop possible and set your focus to include the closest objects, or they will become particularly distracting due to their grainy quality.

Wide angle lenses:

- Include more objects likely to reflect infrared

- Large depth of field aids focusing

Sleepy Hollow: Using the 24mm lens gives the sense that the tree reaches out over the viewer. The area of highest contrast, the dark trunk against the glowing background foliage, draws you deep into the picture at first glance. The headstones show a variety of infrared shifts, depending upon the type of rock and how mossy they are. The grass and the leaves, though both green, produce entirely different tones.

Le Metro: This photo was composed with a 24mm wide angle lens. The combination of lens and fan-shaped subject supplies the viewer with the sensation of peripheral vision. Proper exposure in the straight-line portion of the characteristic curve creates an even spread of tones. The 24mm lens draws you inside this new world without too much wide-angle distortion.

Telephoto lenses:

- Shallow depth of field

- Limit the range of infrared effects included in a photo, e.g. the sky

Telephoto lenses isolate elements from a scene, limiting the range of tones, downplaying the impact of infrared. Objects will still reproduce in unexpected tones, but limiting the subject matter can reduce opportunities for comparison and contrast.

Also, telephoto work in infrared can be tricky because long lenses create a very shallow depth of field. A high f-stop is a necessity and focus becomes critical.

How Do I Design a Composition to Work in Infrared?

In color photography, separation between objects in the frame is achieved simply by placing one color against a different color. In black and white, this is more complicated as two different colors may expose with the exact same tonality and therefore have no separation in your composition. In infrared, this is still more difficult because you are predicting the ultimate

Composition techniques:

- **Place light against dark to achieve separation**

- **Create visual tension with diagonal elements**

- **Balance images by picturing the frame in halves or thirds and confining objects in those areas**

tonalities of objects reflecting invisible light. While this sounds intimidating, begin by making general predictions: What will expose light, dark, or midgrey? Before long, you will find that this experience will lead to more sophisticated and accurate predictions.

A well-composed photograph creates balance in both the compositional lines and the tonality of the image. The mark of a good infrared photographer is the ability to visualize which elements in the frame are going to print dark (blues, browns, dark greens in shadow), and which will emerge brighter than your eye can see (reds, whites, greens in sunlight). Before you settle on a frame, decide which elements will be dark, how dark, and which elements will be light. Then position yourself so the dark elements are next to, or in front of, lighter ones to achieve separation.

The focus of any photograph is the area of highest contrast, where solid black touches a brilliant white. Our eyes are drawn first to this area of a photo. This is the point where your viewer "enters" the image, so you will want to place it properly in your frame to create balance and tension.

As you become more adept at predicting the values of objects in infrared, you will be able to more fully control your compositions.

Fort Ross Fence: The simplicity of this composition makes the viewer respond to the image as an abstract design, a light field cut by a dark diagonal. To the naked eye, this image was not nearly so defined. The green grasses and wooden fence were close in value. When exposed in infrared, the grasses shifted lighter and the wood deepened in tone.

Yosemite Valley From the Four Mile Trail: In this photo, contrast was maximized by finding the position where the sunlit evergreen tree stood out against a dark rock formation. The result was a "white" tree in front of a black rock. Pine trees seldom print white in the way that leafy trees do. To achieve white foliage in an evergreen, the sunlight must be very intense. You can see this effect in the top-lit pine. Only the portions directly struck by the overhead sun turned white, while the partially shaded interior remained a darker tone. For this reason, the carpet of conifers in the valley below appear as mid-grey.

Welcoming Committee: In this photo, I chose a camera height where the penguins' black heads would be against light water, mid-grey grasses against black hills. Note that the placid water exposed a light grey because it was reflecting the overcast sky.

Outside-in Bayeux: These two photos are of the same tree: one taken from within the shade of the tree, looking up at the inside of the leaves; the other taken of the exterior of the tree in bright sunlight. When a leafy tree is struck by sunlight, two things happen. A large amount of infrared reflects back from the sunlit side...

...but a substantial amount of infrared also makes its way through the leaves to the shady underside. The resulting photo is much lighter than either your eye or meter will lead you to believe. This effect is not limited to green leafy trees. Yellow, orange and even deep red leaves have the same effect.

Animals

• **Warm blood is not in the sensitivity range of B&W infrared film**

Warm-blooded animals emanate far infrared radiation (heat), but our infrared film does not respond to this type of infrared. Therefore, animal images will be reproduced in a tonality equivalent to their original color, regardless of their physical temperature.

Kings at Husvik: Although penguins are mammals, and therefore warm-blooded subjects in a cold environment, they do not show up in the print any lighter than expected.

Cashel Cow: This animal's body heat produces no tonal response on infrared film; the areas of light and dark are rendered identically by infrared film and ordinary black and white. Our infrared film is not sensitive to heat; it is simply sensitive to light just beyond our visual capacity. This is "near" infrared, as opposed to the "far" infrared we associate with body heat.

Water

Water usually turns out black in infrared prints. This is especially true of the ocean and lakes, or any body of opaque water which absorbs infrared radiation. Exposure is dependent on either specular reflection from the surface of the water, or reflection through the water off the bottom. If the water looks dark to you, it will expose similarly. If the water is transparent, then the infrared film will represent this.

The tendency of water to go black in infrared is very useful in photographing reflections. For a good reflection, the subject must stand out light against dark and the water must be still and flat.

Chambord: This brilliantly lit edifice easily shows up in the flat black water. The crosslight on this building highlights the details of what would otherwise appear as a starkly symmetrical structure.

Azay-le-Rideau: In this photo, the deep blue of the cloudless sky only deepens the already dark tone of the water. However, the flat reflecting surface creates an ideal situation for balancing the composition. If the building was not reflected, the oppressive black would completely overwhelm the upper portion of the frame, resulting in a morose image. The white patches at the bottom are actually lily pads, highly reflective in infrared.

Nature

In nature, you will encounter various colors of dirt, sand and rock. Your goal is to assess the infrared light that reflects from these areas. Orange, warm browns, and reds are all natural colors to watch out for when creating your compositions. These shades will reproduce lighter than they might appear in the color world.

- Any reddish colors, or colors which contain red, will expose lighter than on non-infrared film.

Giant Sequoia: Reds in nature don't end with earth and rock formations. Trees, barks, leaves, and grasses can all occur in red hues. The trunk of the actual redwood tree is a distinct cinnamon color. In predicting the resulting black and white tone, you might guess a deep grey tone. But as this photo shows, the cinnamon hue reflects infrared better than visible red light, and therefore the tone is much lighter than expected.

Conical Hoodoos: The "Red rock," typical of the Grand Canyon and much of the Southwestern United States, like all red-hued objects, tends to overexpose if you consider only your meter reading. This image was underexposed one stop below the meter's suggestion. This amount of underexposure controls the surprising brightness of these rocks, without compromising the luminous effect. Underexposure by 2-3 stops would lose the effect entirely, with the rocks printing mid-grey.

Snow

Snow is difficult in black and white photography because we expect snow to be pure white. If you expose the negative for pure white snow by allowing it to overexpose a few stops, then the snow will have no texture. In your final print, only the white of the print paper will show through and the contours of the slope will be lost. Underexposure will clue your audience in to the surface texture, but you risk losing the "look" of snow.

To achieve a balance between shocking white, featureless snow and a greyish slope with obvious contours, include some areas of shadow in your composition. This can reveal the snow's texture in small areas, while still giving the impression of a pristine white slope. The long shadows of morning or afternoon crosslight facilitate this technique.

Sentinel Rock: In this example, the snow scene is effectively rendered. The mottled light across the foreground snow reveals detail and texture, while some of the snow is left pure white.

The Sky and Clouds

As in black and white photography, the sky appears darkest when the sun is at your back, and increases in brightness as you turn towards the sun. With the sun at ninety degrees, a blue sky is a pleasantly deep grey. The more the sun comes around in front of you, the whiter the sky will appear. Filters can be used to deepen the sky's tonality.

A dark red or opaque filter will most likely render the sky a deep, rich black when shooting with the sun at your back. Keep this in mind for composition decisions, as a black sky can easily overwhelm your image. However, the pure white of clouds superimposed on the deep black of the sky can be quite captivating.

There are sometimes more clouds in the sky than we can see. Wispy clouds, such as mare's tails, are frequently a clue to this atmospheric condition. In these situations, shoot a few extra frames. You might capture spectacular cloudscapes on what seems an ordinary day.

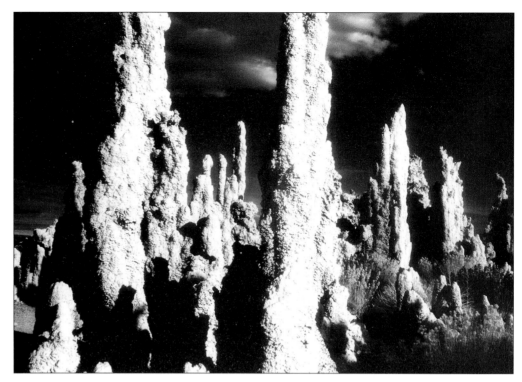

Tufa Towers, Mono Lake: With sun behind the camera, the sky goes nearly black. Because of cloud cover, the foreground subject was directly illuminated, but the patch of clouds was actually in shadow. By overexposing the foreground towers, graphic contrast was created, breaking up the dark background.

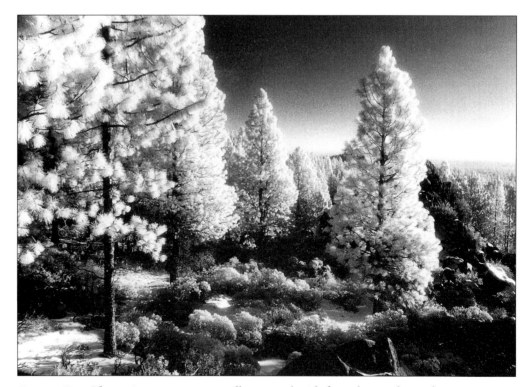

Frozen Firs: These pine trees are actually covered with frost, hence their white appearance even in partial shadow. The crosslight of morning, plus patches of snow in shaded areas, gives the image an unusually broad range of values. The sun is at a 90° angle to the right, causing the sky to expose mid-grey.

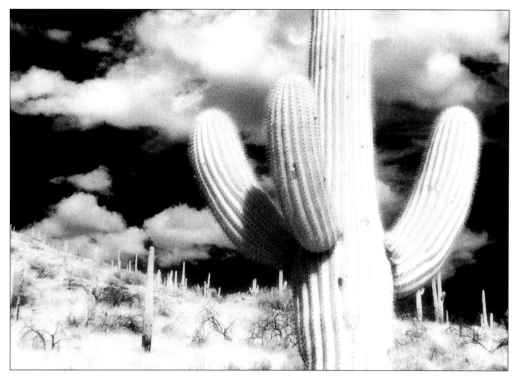

Saguaro: With front light on the green cactus, the cactus appears white. The sky in the background is black, nicely broken up by the clouds. Creativity does not stop at exposing the negative. This photo can be printed a number of ways. The cactus can be anything from a glowing white down to a realistic grey tone.

Section IV:

Reviewing What You've Learned

Mastering the concepts in the previous chapters will take some time and practical experience. To facilitate this process, this section condenses the numerous techniques and theories into a workable approach for successful infrared photography.

CHAPTER NINE

Previsualizing Your Work

The concepts covered in this book can be simplified to a three step process. While this may initially seem unwieldy, walking yourself through this process will help to build your intuitive understanding of what can make a successful photograph. And even after you have gained confidence, you can still use this regimen to tame particularly complex situations.

1) Interpret the scene: source light and reflected light

2) Consider your tools: filters, film, exposure

3) Shoot

The first two steps are critical, and they have nothing to do with your camera. Instead, they have to do with the photographer's eye and his or her ability to see the picture before the shutter is fired. This previsualization process, outlined below, will help you to achieve images that express your personal vision.

(1) Interpret the Scene

The first step of previsualization is taking inventory of the visible and invisible nature of your scene. In this phase, you are concerned with the scene as it exists, which is completely separate from the scene as it will be recorded on film.

When examining your subject, consider the light source and light reflected from your subject:

Source light, the light illuminating your subject:

- If it is a natural source, it contains both visible and infrared light. Remember, time of day, atmospherics and the type of source can greatly shift the infrared content of natural light.

- If the illumination is artificial, it may or may not contain infrared light. Consult chapter 4 for tips on how to evaluate whether it is a relatively rich or weak infrared source.

Reflected light, the light you perceive as color and which exposes your film:

- The visible color of your subject can give you a clue as to what portion of the source light your subject will reflect.

- Foliage, reddish objects, and synthetic materials are likely to reflect infrared light.

- The sky, dark-colored natural fiber materials, and bodies of water may reflect only visible light and no infrared light. These objects will expose darker than they appear.

- Black, blue and purple dyes often contain reddish hues. These dark objects can unexpectedly reflect a lot of infrared. The film will record these objects lighter than they appear.

(2) Consider your tools: Film, Filters, Exposure

The many decisions involved in infrared photography are opportunities to express your photographic style. With a small selection of tools you can achieve a wide variety of photographic looks.

Your choice of tools can be settled before you set out, or you can wait and alter your techniques while in the field. Ideally, some consideration should be put into every shot you take, as subject and conditions change throughout a roll.

•Film — Kodak or Konica?

These two manufacturers of infrared film stocks provide you with remarkably different tools. Both films have advantages that you must consider before deciding which stock will be best for your style or specific project.

Konica provides a high contrast look to sharpen otherwise dull images. Both the orange #15 and the red #25 filters totally block the visible component for this film, leaving only an infrared exposure. This limits the range of values you can achieve, especially in rendering the sky. Start with ASA 25 through the orange filter. This slow speed often makes a tripod necessary, but rewards you with fine grain.

Kodak infrared's ASA of 200 through the red filter is fast enough for shooting in most lighting situations without a tripod, making this film more useful for action and street photography. An advantage to using Kodak is the ability to achieve a variety of looks by either altering exposure or changing filters. Overexposure produces low contrast, grainy images while underexposure results in high contrast, fine-grained photos.

You can achieve fine results with both types of film. The choice is a creative one.

•Filters

Your filter choice ranges from the simple UV blocking of a skylight/haze filter, to the yellow, orange, red, and finally the visibly opaque infrared filters.

You can determine exactly where you want to cut off the film's sensitivity and use a filter to achieve this. You can expose for a white, light grey, dark grey or black sky, or you can choose to eliminate all visible light by utilizing an opaque infrared filter.

In order to select the proper filter:

- Consider which elements in your scene will be affected by each type of filter. For example, if a red truck is parked in front of a blue wall, a yellow filter will not create enough separation between them. However, an orange filter will block the blue light while allowing the red to pass through to the film, resulting in a bright white truck in front of a dark wall.

- Determine whether there is any light you want to block with a specific filter choice. If shooting outdoors, you might want to block the UV and blue portion of the spectrum. This can be achieved with a red filter.

- Choose the filter that will enhance the qualities of the scene you are trying to capture. For example, if a black sky will overpower your composition, don't use anything darker than an orange filter.

•Placement on the Curve — Exposure

When using Kodak High Speed Infrared, you have control over whether your photograph will be full of grain, or finer grained with higher contrast. All you have to do is decide where along the characteristic curve you will expose your negative. For a fine-grained, contrasty look, underexpose the film, using the toe portion of the curve. Placing the exposure on the shoulder will result in an overexposed, grainy image.

With Konica, you must expose in the straight line portion. The abrupt transition at the shoulder and toe limits the usefulness of these areas of the negative.

(3) Shoot

You have studied the elements in the scene and considered the possible results given the tools available. There are many variables involved; the key is not to let anything happen by chance. To previsualize the picture in detail, ask yourself the following questions:

- Where will I place the infrared reflective elements within the frame? How will this reflected infrared light affect the balance of my composition?

- Does the source light contain wavelengths of light I want to block? Which portions of the spectrum do I wish to include? Or should I use an opaque filter to block all visible light?

- Will the contrast be high or low? Am I going for an ethereal, grainy look, or a high contrast, sharp image? Remember, this will be determined by exposure or film choice.

Now, shoot!

The Evolution of Style

Successful photographers learn to predict how the scene will expose their film. As you gain facility with this skill, you will achieve a higher success ratio with each roll you shoot, avoiding rolls of marginal negatives interspersed with lucky shots. It is the understanding of how each element will expose that will enable you to further control your compositions and ultimately make you a better photographer in both infrared and visible photography.

It has been my intent not to teach how I shoot infrared, but to share the experience I have gained in making the images seen in this book. Hopefully, I have changed your view of infrared photography from something spectacular but unpredictable, to a type of photography which you can approach with confidence.

Once you are able to look at your photographs and know why they succeeded or, more importantly, why they did not, you are well on your way to mastering infrared photography. When this is achieved, infrared film becomes a uniquely flexible photographic tool for interpreting how you see the world.

Experiment. Shoot the same subject in different ways with the intention of getting different specific results. Try underexposing, overexposing or shooting at sunset rather than at midday. You can gain as much from a disastrous roll of infrared as a perfect one, as long as you are able to puzzle out the reasons behind the results.

As your stack of proof sheets grows, you will find your confidence in your ability to predict the infrared film's response will also grow. Each time you previsualize a photo, decide how to expose and shoot a frame, you are carving out your own style in infrared photography.

Section V:

Appendices

Darkroom Techniques

Film Care and Storage

Film Warm-Up Times

Airport X-ray Machines

Batch Testing

Auto Focus

Filters

Film and Filter Manufacturers

Darkroom Techniques for Infrared

Developing Procedures

There is no "safe" light for infrared film. You must handle the negative in total darkness. Place the film in metal development tanks, as plastic ones may not protect your negative from infrared radiation and exposure. Once the negative is threaded and in the tank, you may turn on the lights.

Processing Chemicals and Times										
Kodak Developer	Approximate Developing Time in Minutes									
	Small Tank -- Agitation at 30 second intervals					Large Tank -- Agitation at 1 minute intervals				
	65°F 18.5°C	68°F 20°C	70°F 21°C	72°F 22°C	75°F 24°C	65°F 18.5°C	68°F 20°C	70°F 21°C	72°F 22°C	75°F 24°C
D-76	13	11	10	9.5	8	14	12	11	10	9
HC-110 (Dilution B)	7	6	6	5.5	5	7	6.5	6	5.5	5
D-19 (for maximum contrast)	7	6	5.5	5	4	8.5	7.5	6.5	6	5

Drying the Negative

If you are developing your own negative, you will discover the Kodak infrared negative tends to maintain its curl longer than other films. This is due to the thin film base and lack of anti-curl backing. Before making your proof sheet, let the film hang an extra day. This will minimize the curl and make it easier to work with in the darkroom.

Working with the Negative while Printing

Kodak negatives are difficult to handle and hard to get flat, particularly the frames at the ends of the strips. Use a glass negative holder to minimize out of focus corners in your prints. If you don't have one, compensate by printing at the highest f-stop possible to increase your depth of field.

Airport X-Ray Machines

In modern airports, you should have no qualms about letting your infrared film go through the x-ray machines. The x-ray wavelengths are far beyond the film's sensitivity for exposure.

In older airports it is a good idea to ask that all your film be hand searched because older x-ray machines cannot always be trusted. International Air Traveler's Association (IATA) guidelines give you the right to hand inspection, so don't let them bully you into putting your film through a rickety looking x-ray machine.

A bigger threat is that the security guards will insist on opening up your canisters to verify that they contain film. If they insist, you must convince them to open the canisters only within a black bag. This can be difficult in foreign countries where you might not speak the language, so prepare yourself ahead of time; and have the black bag handy to facilitate the process.

Batch Testing

Kodak manufactures their film once a year. If you are going to a lot of expense to shoot some infrared, perhaps traveling a long distance, I suggest you purchase the film and shoot a test roll before you embark on your expedition. Make sure each roll is marked with the the same batch number or expiration date. Shoot one roll and compare its performance with the infrared you have shot in the past. If the results are similar, then your ASA and filter choices are affirmed. If the new roll is over or underexposed, alter your ASA to compensate for the differences between batches. I have experienced some fluctuations in exposure between batches (but never within), so it is a good idea to make a test.

If you come across a batch that you like, you can purchase a supply of rolls and store them safely in your freezer. If properly sealed in a plastic bag to control moisture and humidity, freezing will slow down the aging process and the film will not experience any noticeable deterioration. I have used film stored in this manner two years past its expiration date and it was not visibly affected.

Auto-Focus

Infrared film focuses at a different point than visible light. If you have a camera without manual focus, you won't be able to adjust for this difference. Check your camera manual for instructions on how to focus (and lock) on something just short of your actual subject, then reframe and shoot. The required infrared shift in focus is much more pronounced with wide lenses rather than long. For example, if you have an auto focus 200mm, the change will be minimal. The easiest way to guarantee a sharp image is to shoot with a large depth of field.

Available Filters, Their Uses and Effects:

filter	description	effect
UV	clear	filters out ultraviolet for haze control
#8	medium yellow	slight increase in contrast
#15	orange	deepens sky value without creating extreme contrast
#25	red	both red filters provide strong contrast in landscape, with very deep sky values
#29	dark red	
#87	opaque infrared	all three opaque filters transmit no visible light, create an extreme infrared effect with
#87C	opaque infrared	high contrast and black sky, and will not expose under fluorescent lighting
#88A	opaque infrared	

Exposure Adjustments for Standard or Infrared Photography:

Increase exposure by # of *f*-stops listed on chart

filter	Infrared film	Black and White Films
UV	0	0
#8	1	1
#15	1 1/2	1 2/3
#25	2	3
#29	2	4 1/3
#87	3	n/a
#88A	3	n/a
#87C	12+	n/a

Manufacturers of films and filters

Infrared Films:

Eastman Kodak Company

 Rochester, New York 14650
 Information Center: 1-800-242-2424

Konica U.S.A., Inc.

 440 Sylvan Avenue, Englewood Cliffs, NJ 07632
 201-568-3100
 Technical Information: 1-800-285-6422

Filters:

Eastman Kodak 213-464-6131; 1-800-242-2424

Harrison & Harrison 209-782-0121

Heliopan HP Marketing 201-808-9010

Schneider (B&W) 516-496-8500

Tiffen 1-800-645-2522

Tokina-Hoya 310-537-9380

Glossary

amplitude — The distance from zero to the maximum height of a curve during one period of oscillation. This is measured on the vertical axis of a graph.

anti-curl backing — A type of film base which minimizes the curl of the negative after processing.

anti-halation backing — An opaque layer on the back of the film base that prevents bright points of light from bouncing back onto the emulsion and creating halos around bright objects.

ASA/ISO (American Standard Association/International Standardization Organization) — A rating system used to set light meters to correspond with a film's sensitivity.

backlight — A light that illuminates the scene from behind the subject. This can cause lens flares and, when used as the only light in the scene, will result in a silhouette.

base make-up — An overall coating of the face in order to even out skin tone, hide blemishes and freckles.

base fog — The inherent density of a developed piece of film caused by factors other than light — age, temperature, etc.

black body — A hypothetical object that absorbs without reflection all of the electromagnetic radiation striking it.

bracketing — Photographing a scene several times, each time changing the exposure by one or two stops, to ensure that one of the exposures is the proper one.

broad band — Filters with a gradual change in transmission characteristics.

characteristic curve — A graph showing how a specific film responds to equally increasing amounts of light. It illustrates the film's latitude and contrast, and can be used to determine the proper ASA/ISO.

color balance — The specific lighting conditions for which a film is designed to reproduce colors accurately. Most commonly, films are "balanced" for daylight or tungsten light.

color temperature — A system of defining the color of a light source by comparing it to a theoretically perfect temperature radiator called a "black body."

compression — When exposure values of varying intensities are reproduced at closer intervals or as a single value.

continuous spectrum — Light sources which emit energy across all the wavelengths of the photographic spectrum.

crosslight — A light that illuminates the subject from the side. When used as the only light in the scene, this will result in a high contrast image.

density — The variable thickness of a film's emulsion after processing due to the degree of exposure.

depth of field — The distance, both behind and in front of the point at which the camera is focused, within which objects will appear sharp.

discontinuous spectrum — Light sources such as fluorescent tubes, which emit energy in only a few wavelength bands of the spectrum. Some colors of light are not present in the discontinuous spectrum.

DX coding — A bar code version of ASA/ISO numbers on film canisters. Automatic cameras use this to set their light meters.

electromagnetic spectrum — The entire range of energy radiated by the sun. This includes electric, magnetic, and visible radiation, with wavelengths ranging from .001 angstrom (gamma rays) to more than 1 million km (long waves).

far infrared radiation — Invisible to the eye, light with wavelengths of 1200nm to 1mm. This is the infrared we perceive as heat.

filter factor — A number by which the exposure must be multiplied to compensate for the light absorbed by a filter.

flashing — Unintentional exposure of a roll of film. Sometimes performed in a controlled and consistent manner to lessen the contrast of a film.

fluorescent light — A phosphor-coated, tube-shaped bulb in which light is produced by an electrical discharge that causes the coating to glow.

fogging — Film density caused by unwanted exposure to heat or light.

gel filters — Colored coatings on a plastic base for use on light fixtures or on a camera lens (with the proper holder).

halation — A halo-like flare surrounding bright objects on film. Halation is caused by light reflected from the film base.

HID lamp (High Intensity Discharge) — Any industrial lamp that produces light by discharging an electrical arc through pressurized gas or vapor. Types of HID lamps include: mercury vapor, metal halide and sodium vapor lamps.

high contrast — Where the density differences in the reproduction are greater than the brightness differences in the original subject, resulting in a "hard" look.

incandescence — The glowing of a body due to its higher temperature; a reference to the glow from a filament lamp.

incandescent lamp — A lamp that emits light due to the glowing of a heated material, especially the household lamp in which a tungsten filament enclosed within an evacuated glass bulb glows when electricity passes through it.

incident meter — A light meter which is used to measure the light actually striking the subject. This is typically a hand-held meter. (See reflected light meter.)

Kelvin — A temperature scale where zero in degrees Kelvin equals -273 degrees Celsius (absolute zero).

latitude — The range of brightness (exposure) a given emulsion can accommodate to produce satisfactory pictures.

low contrast — Where the density differences in the reproduction are less than the brightness differences in the original scene, resulting in a "soft" look.

Name_____
Address_____
City_____State_____
Zip_____ — _____

Place
Postage
Here

Amherst Media, Inc.
PO Box 586
Amherst, NY 14226

Amherst Media's Customer Registration Form

Please fill out this sheet and send or fax to receive free information about future publications from Amherst Media.

CUSTOMER INFORMATION

DATE

NAME

STREET OR BOX #

CITY STATE

ZIP CODE

PHONE ()

OPTIONAL INFORMATION

I **BOUGHT** *INFRARED PHOTOGRAPHY HANDBOOK* **BECAUSE**

I FOUND THESE CHAPTERS TO BE MOST USEFUL

I PURCHASED THE BOOK FROM

CITY STATE

I WOULD LIKE TO SEE MORE BOOKS ABOUT

I PURCHASE BOOKS PER YEAR

ADDITIONAL COMMENTS

FAX to: 1-800-622-3278

Basic 35mm Photo Guide
Craig Alesse

For beginning photographers! Teaches 35mm basics step-by-step. Completely illustrated. Features: 35mm automatic and semi-automatic cameras, f-stops, shutter speeds, composition, and lens & camera care. $12.95 list, 9 x 8, 112 p, 178 photos, order no. 1051.

Into Your Darkroom Step-by-Step
Dennis P. Curtin

The ideal beginning darkroom guide. Easy to follow and fully illustrated each step of the way. From developing black & white negatives to making your own enlargements. Full discussion of: equipment, setting up the darkroom, making proof sheets, special techniques for fine prints, & more. $17.95 list, 8 1/2 x 11, 90 p, hundreds of photos, order no. 1093.

The Wildlife Photographer's Field Manual
Joe McDonald

The classic reference for wildlife photographers. A complete how-to, including: lenses, exposure in the field, focusing techniques, and more. Tips and special sections about sneaking up on animals, close-up photography, aquarium shots, and more. Joe McDonald is one of the world's most accomplished wildlife photographers and a trained biologist. $14.95 list, 6 x 9, 208 p. order no. 1005.

Make Fantastic Home Videos
John Fuller

Create videos that friends and relatives will actually want to watch! After reviewing basic equipment and parts of the camcorder, this book tells how to get a steady image, how to edit while shooting, and explains the basics of good lighting and sound. Sample story boards and storytelling tips help show how to shoot any event. $12.95 list, 7 x 10, 128 p, fully illustrated, order no. 1382.

Basic Camcorder Guide/ Revised Edition
Steve Bryant

A great book for anyone with a camcorder, or those who want to get one. Easy and fun to read. Packed with up-to-date info you need to know. Includes: selecting a camcorder, tips on giving your videos a professional look, camcorder care, advanced video shooting techniques, and more. $12.95 list, 6 x 9, 96 p, order no. 1239.

Underwater Videographer's Handbook
Lynn Laymon

Diver, instructor and videographer, Lynn Laymon, shows how to get started and have fun shooting professional-quality underwater videos. Fully illustrated. Step-by-step instruction on: buying equipment, planning dive strategies, underwater composition & lighting, video editing & post production, marketing your underwater video skills, and much more. $19.95 list, 8 1/2 x 11, 128 p, over 100 photos, order no. 1266.

Infrared Nude Photography
Joseph Paduano

A stunning collection of natural images with wonderful how-to text. Over 50 rich duotone infrared photos. Shot on location in the natural settings of the Grand Canyon, Bryce Canyon and the New Jersey Shore. $18.95 list, 9 x 9, 80 p, over 50 photos, order no. 1080.

Build Your Own Home Darkroom
Lista Duren & Will McDonald

This classic book shows how to build a high quality, inexpensive home darkroom almost anywhere. Complete discussion on: design, woodworking, tools, building techniques, ventilation and more. Covers everything you'll need, including: enlargers, lightboxes, darkroom sinks, water supply panels, and print drying racks. $17.95 list, 8 1/2 x 11, 160 p, order no. 1092.

The Freelance Photographer's Handbook
Fredrik D. Bodin

A complete and comprehensive handbook for the working freelancer (or anyone who wants to become one). Full tips, techniques and strategies. Chapters on marketing, customer relations, inventory systems & procedures for stock photography, portfolios, plus a special section aimed at increasing the marketability of your work. $19.95 list, 8 1/2 x 11, 160 p, order no. l075.

Camera Maintenance & Repair
Thomas Tomosy

A step-by-step, fully illustrated guide by a master camera repair technician. Sections include: general maintenance, testing camera functions, basic tools needed and where to get them, basic repairs for accessories, camera electronics, plus "quick tips" for maintenance and repair of specific models. $24.95 list, 8 1/2 x 11, 176 p, order no. 1158.

Camcorder Tricks & Special Effects
Michael Stavros

Turn you camcorder into a toy using over 40 tricks and effects! With only a camcorder and simple props, you can simulate effects used by Hollywood pros. Each trick tells what you'll need, and shows the simple steps to getting results. It's so easy, the whole family can join in the fun — even Rover! Make your videos an adventure to watch. $12.95 list, 7x10, 128 p, order no. 1482.

Guide to Photographing California
Al Guiteras

100's of the best photo opportunities in California! Listings rated with from 1 to 5 film canisters, signifying the overal image potential and the amount of film needed. Cover climate, local photo retailers & tips on shooting in diffic lighting conditions. $9.95 list, 6x9, 144 p, order no. 1291.

Infrared Photography Handbook
Laurie White

Totally covers infrared photography, including equipment, shooting your first roll and filters. Illus how IR film reacts in all types of photograph examples to show how IR can create a photo dreamscape. Includes technical and artistic cri sample images. $24.95 list, 8 1/2 x 11, 104 p, photos, charts & diagrams, order no. 1383.

Third Edition

THE ART OF INFRARED PHOTOGRAPHY

JOSEPH PADUANO

A COMPREHENSIVE GUIDE TO THE USE OF BLACK & WHITE INFRARED FILM

The Art of Infrared Photography

Joseph Paduano

". . .escorts the reader into a fascinating area of photographic experimentation!" – New York Times

". . .49 dream-like images. . .A thoroughly useful introduction!" – Photographer's Forum

*The ideal companion book to the **Infrared Photography Handbook** by Laurie White.*

A complete, straightforward approach to B&W infrared photography for the beginner and professional. Includes a beautifully printed portfolio. Features: infrared theory, precautions, use of filters, focusing, film speed, exposure, night & flash photography, developing, printing and toning. $17.95 list, 9 x 9, 76 p, 50 duotone prints, order no. 1052.

Write or fax for a _FREE_ catalog
Amherst Media, Inc.
PO Box 586
Amherst, NY 14226 USA
Fax: 716-874-4508

See Next Page For More
Amherst Media Books ☞

Index

shoulder — The high density region of the sensitometric curve, or overexposure. This is where further exposure does not produce any appreciable increase in density.

sodium vapor — An HID lamp, typically found in parking lots, roads, high school gymnasiums, in which sodium is added to the gases. Visually, the light is characterized by a yellow glow, and is greatly lacking in blue and green. Infrared emission is negligible and ultraviolet transmission is nonexistent.

source light — The light, whether natural or artificial, which illuminates the subject of the photograph.

spectral energy distribution (sed) — The relative amount of energy emitted by a light source across the wavelengths of the photographic spectrum.

spectral sensitivity — A given film's response to each wavelength of light within the photographic spectrum.

spectral sensitivity curve — A graph of a specific film's response to colors/wavelengths across the photographic spectrum.

spectrophotometric curve — A graph of the light transmitted by a specific filter across the photographic spectrum.

spot meter — A type of reflected-light meter which reads a tiny portion of the scene.

straight-line — The region on the sensitometric curve along which the film accurately reproduces the range of tones in the scene.

toe — The low density region of the sensitometric curve, or underexposure. This is where dark tones become indiscernible from the base fog of the film.

transmission — The percentage of each wavelength that passes through a given filter.

tungsten halogen — An incandescent lamp containing a regenerative element that prevents the darkening of the bulb over time. This guarantees a fairly constant color temperature of 3200°K over the life of the bulb.

tungsten light — A general term referring to indoor burning filament lamps, with color temperatures ranging from 2800°K to 3400°K.

ultraviolet light — Invisible to the eye, light with wavelengths from 1 to 380nm. The portion of the electromagnetic spectrum just short of visible violet light that the human eye perceives.

underexposure — Most of the brightness range of the subject is placed on the toe portion of the negative material. Not enough light reaches the emulsion to accurately reproduce the subject matter.

visible spectrum — The 380 to 730nm portion of the electromagnetic spectrum which produces in the human brain a sensation of light. The visible spectrum is divided into the color ranges: violet, blue, green, yellow, orange, red.

wavelength — The distance between the crest of one wave to the next. Every different wavelength identifies a different portion of the electromagnetic spectrum.

white light — Light perceived by the eye as having the same color as sunlight at noon. Generally, white light is the result of the combined luminance of all the colors of light.

mercury vapor — An HID lamp, typically used in department stores and shopping malls, which emits a bluish white light with no red or infrared radiation. When viewed by eye, blue, green and yellow will appear to be brighter than they really are and orange and red will appear a muddy brown.

metal halide — An HID lamp with metal halides added to the gas or vapor to create what is technically a continuous spectrum lamp, but one which has all the characteristics of a discontinuous source. The energies peak drastically in violet, blue, green and yellow, and the infrared component is functionally nonexistent.

nanometer (nm) — One billionth of a meter (10^{-9}). A measure of wavelength.

near infrared radiation — Invisible to the eye, light with wavelengths from 730 to 1200nm. The portion of the electromagnetic spectrum just beyond visible red light that the human eye perceives.

neon lamp — Glass tubing containing two electrodes and a gas which emits a glow when a voltage is applied across the electrodes.

opaque filters — Filters that are opaque to the human eye. These filters can be transparent to invisible light (such as infrared) which passes through the filter to expose the film.

orthochromatic film — Black and white film emulsion sensitive to only blue and green light.

overexposure — Most of the brightness range of the subject is placed on the shoulder portion of the negative material. Too much light reaches the emulsion to accurately reproduce the subject matter.

panchromatic film — Black and white film emulsion sensitive to the entire visible spectrum from violet (380nm) to red (730nm).

photographic spectrum — The 1 to 1200nm portion of the electromagnetic spectrum to which photographic materials are designed to respond.

prism — A transparent solid body used for separating white light into its component colors, creating a spectrum of visible colors.

proper exposure — Most of the brightness range of the subject is placed along the straight line portion of the negative material. This results in an accurate reproduction of tones.

quartz halogen — A tungsten halogen lamp whose bulb is made of quartz and produces light with a color temperature of 3200°K.

reflected light — The light that bounces off and is not absorbed by the object to be photographed. This light can only include wavelengths (colors) occurring in the source light.

reflected light meter — A light meter which is used to measure the light reflected from the subject. This is the type of meter built into cameras. (see incident meter)

sensitometric curve — A graph which shows how the increasing amounts of exposure on a negative increase the density of a film's emulsion after development. The sensitometric curve for a particular film is called a characteristic curve.

sharp cutting — Filters with an abrupt change in transmission at a specific wavelength.